CU00661247

SAILING SHIPS OF THE BRISTOL CHANNEL

Viv Head

AMBERLEY

Front cover: The 1909-built Bristol Channel pilot cutter *Dolphin* off Barry in 2016. Photo by Viv Head: a nomadic Welshman, part-time historian, author, occasional artist and fine-weather sailor of small boats.

First published 2017

Amberley Publishing
The Hill, Stroud,
Gloucestershire, GL5 4EP

www.amberley-books.com

ISBN: 978 1 4456 6400 2 (print)
ISBN: 978 1 4456 6401 9 (ebook)

British Library Cataloguing in Publication Data.
A catalogue record for this book is available from the British Library.

Typeset in 10pt on 13pt Celeste.
Origination by Amberley Publishing.
Printed in the UK.

Contents

About this Book

Some of the sailing ships portrayed in this book are particularly large, such as the SS *Great Britain*, while others are smaller, like the diminutive *General Picton*. There are different definitions of a 'ship' but British merchant maritime law distinguishes between 'registered ships' and 'small ships under 24 metres in length'. No minimum size is used to define a 'ship' but it is understood that any vessel propelled solely by oars is a boat rather than a ship. A sailing ship is, therefore, a ship of any dimension.

Many thousands of ships have sailed the waters of the Bristol Channel. I have selected a few – those of a different design or that had a different job, or simply some because of the stories that lay behind them. Many I already knew, others were a joy to discover; ships that were built locally, traded, raced, visited or set out on great voyages of discovery. Some were deep-sea sailing merchantmen or sleek greyhounds of the sea; others were simply workhorses earning their keep in a notorious stretch of water. They may have sailed the Bristol Channel, but in reality they are all part of a remarkable worldwide maritime history.

Acknowledgements

Thank you to all those who willingly provided images or information. Many of the photographs included are my own; every effort has been made to assign correct acknowledgement to other photographs and material used. If it is found that material has been used without permission or acknowledgement, then full apologies are offered and correction will be made at the next opportunity.

In particular, I wish to acknowledge the following:

Viking Ship Museum, Denmark (Copyright two Viking ship images), Falkland Islands Museum, SS *Great Britain* Trust, National Trust of Australia (Victoria), Salcombe Maritime Museum, Tom Cunliffe (www.tomcunliffe.com/product/pilot-cutters-under-sail), Warrior Preservation Trust, West Wales Maritime Heritage Society, Mark Grimwade, Gareth Mills Collection Swansea, Padstow Museum Trust, Challenge Wales, Tenby Museum & Art Gallery, Ironbridge Gorge Museum Trust, Classic Sailboats, and World of Boats Cardiff.

But soon I heard the dash of oars,
I heard the Pilot's cheer
My head was turned, perforce away
And I saw a boat appear
The Pilot and the Pilot's boy
I heard them coming fast
— 'The Rime of the Ancient Mariner' by Samuel Taylor Coleridge,
Written in 1798 in the Bristol Channel port of Watchet.

The Bristol Channel

At a known point, Britain's longest river, the Severn, widens into the Severn Estuary, which in turn becomes the Bristol Channel. As the channel grows wider it becomes the Celtic Sea before losing itself in the North Atlantic. In common usage, however, the whole of the widening estuary is invariably referred to as the Bristol Channel, and it is this interpretation that has been used to include ships recorded in this book.

With a tidal range of over 14 metres (46 feet), it has a maze of banks and narrow channels in the upper reaches, and broadens to a comparatively shallow estuary. The prevailing wind is westerly so that, when the tide is on the ebb, wind over tide conditions often mean short, steep seas crested with grubby spume. A malevolent chop sets in to test the unprepared mariner. When the wind blows strong, it is not always a good place to be. Yet it has an incredibly rich history of exploration, trade, ingenuity and design. Pilot cutters, built on the English and Welsh sides of the channel, are renowned right around the globe. South Wales was the crucible of Britain's industrial revolution and, for best part of a hundred years, its coal ports fed the trade routes of the world. In the days before engines, masters of coastal vessels and pilot cutters took pride in their craft in every sense of the word. Bringing a vessel under sail alongside a wharf without mishap took knowledge, timing, expertise and a cool head. Such men were indeed master mariners. Without a doubt, Bristol Channel sailors and their ships have put their mark on history.

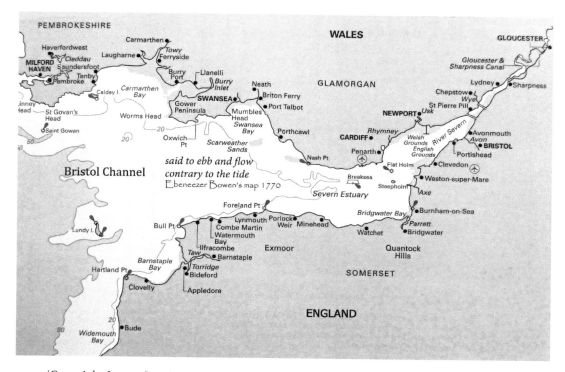

(Copyright Imray, Laurie, Norie & Wilson Ltd)

1

The Pioneers

Viking Ships

It is well known that the Vikings explored the Bristol Channel; the islands of Ramsey, Skokholm, Steep Holm, Flat Holm and others bear witness. Indeed, the Vikings settled locally to farm in Somerset and Glamorgan, and some of their descendants may still be there. We do not know precisely which ships came to explore the far reaches of this body of water, but we do know of their type.

Roskilde in Denmark is a small town that, in its day, was more important than Copenhagen. Roskilde Haven is a wide, rather shallow, expanse of water with only three navigable channels. Local fishermen had always known there was some sort of wreck lying in the main channel, but it wasn't until the 1960s that it was properly investigated. What the divers found was quite extraordinary; they discovered five Viking ships that had been stripped and deliberately sunk as block ships to prevent enemies reaching the town. The process of careful removal and preservation took twenty-five years. Even more extraordinary, thanks to a worldwide database of tree rings' DNA, it has been established beyond doubt that the largest of them, *Skuldelev 2*, which was 98 feet in length, was built in Dublin from timber felled in the summer of the year 1042. Since it was deliberately sunk in Roskilde Haven, it must have crossed the North Sea at least once and had almost certainly ranged far and wide before that. So who is to say that a Viking ship built in Dublin did not venture up the Bristol Channel, her dark woollen sail, wind proofed with ochre and animal fat, billowing before a strong prevailing westerly wind? If not this one, then one very much like it.

Reconstructions of all five block ships have been built in Roskilde and, in 2007, the glorious Viking longship *Sea Stallion of Glendalough* set sail across the North Sea, bound for Dublin, to complete a return voyage, albeit a thousand years late.

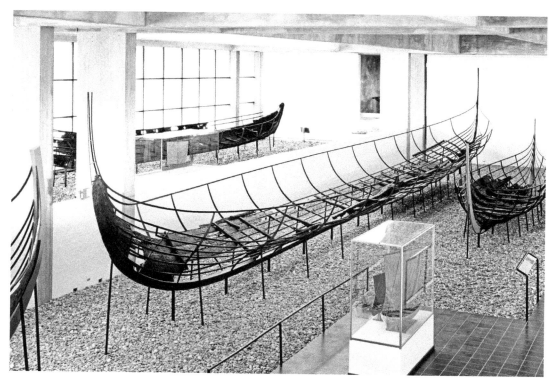

Viking ship *Skuldelev 2*, raised from the seabed at Roskilde Haven. (Werner Karrasch)

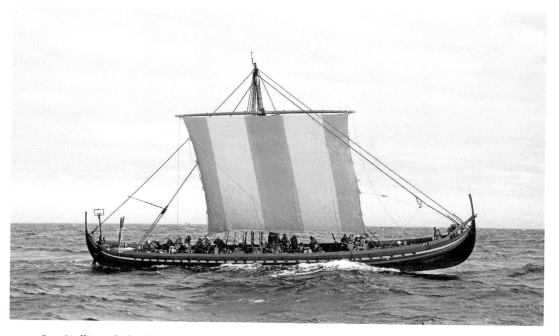

Sea Stallion of Glendalough, replica of the Viking ship built in Dublin. (Werner Karrasch)

The Newport Ship

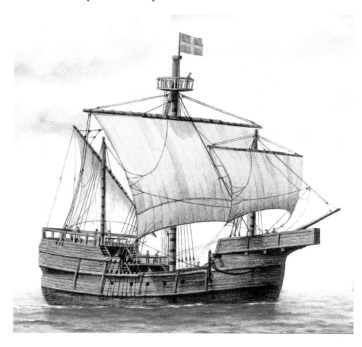

Wonderful illustration of how the Newport Medieval Ship may have looked. (Peter Powers)

You never know what you might find when fossicking about in the mud. One summer's day in June 2002 Lee Davies was working on the foundations of the Riverfront Arts Centre on the banks of the River Usk at Newport when he spotted timbers lying in the mud. He called foreman Dan Bowles over and the two men peered down at the hole in the mud. They knew immediately that it was something special; Don called a halt to work and rang Newport Museum. The archaeologists arrived the next day, and so began an extraordinary tale. For what Lee Davies had spotted were the timbers of a ship more than 500 years old – a ship of international importance that was sailing the Bristol Channel before John Cabot set off to discover America in the *Matthew*. When finally excavated, it was found to be the most complete fifteenth-century ship surviving anywhere in the world – a large trading ship, perhaps capable of carrying 200 tons of cargo, built in the Basque country of Northern Spain *circa* 1450. A French coin, minted in 1447, was found embedded in timber between the keel and the sternpost. It was established that the vessel had been moored in a form of dock, either for repair or dismantling, when it was abandoned; the masts and spars had been removed. Supporting struts underneath the ship were carbon dated to *c.* 1470, suggesting the ship had a seagoing life of about twenty years. The vessel was empty of cargo and ballast but there were still some remarkable finds within it. These included fish bones, Portuguese coins, beeswax, and remnants of cloth and rope as well as stone shot, indicating that the vessel may have been armed. They also found wooden 'knees', showing that the vessel had a deck and may have had an upper deck. There were little or no personal possessions but a remarkable leather pointed poulaine shoe, fashionable in the fifteenth century, was discovered in iron slag beneath the ship.

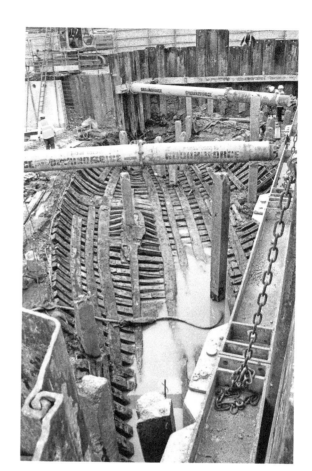

Right: The Newport ship, as discovered in 2004. (Nigel Nayling)

Below: A remarkable find buried beneath the ship. (Rex Morton)

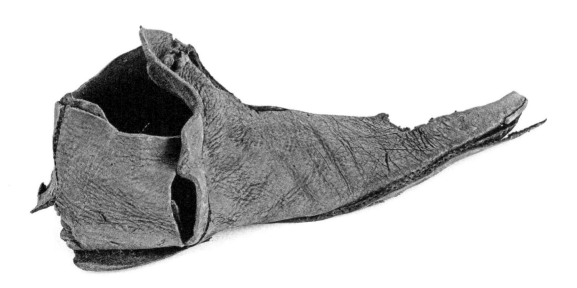

Work on the site was halted for five months while the timbers were taken away, nearly 2,000 of them, piece by piece. So began the cleaning, recording and conservation of the timbers that have continued ever since. The final conservation process, freeze drying, is under way at the York Archaeological Trust. All fully conserved timbers are expected to be back by the end of 2018, when the business of putting the medieval ship back together will begin.

What did the ship look like? An intriguing question, for which more accurate ideas have emerged as more information has come to light. How many masts did she have? That is still speculative but the best guess now is three: a main mast in the centre and smaller masts towards the bow and the stern. Peter Powers, a renowned marine artist, produced the superb painting that is believed to be a good representation of how she once looked. There has been much deliberation and speculation about where the Newport Ship will finally be displayed. The third floor of the Newport Museum and Art Gallery is being seriously considered, although there are some engineering implications to be taken into account.

Matthew

When John Cabot sailed out of Bristol early in 1497 he was embarking on a voyage of discovery that was to be one of the greatest ever undertaken. His vessel has been said to be the most important ship in the English language. While Christopher Columbus seems to have cornered the glory, it was John Cabot who discovered and landed upon mainland America. His one small ship, the *Matthew*, crossed the wild North Atlantic against the prevailing winds, encountering icebergs and the notorious Grand Banks fog. By landing on what we know today as the aptly named Newfoundland, he became the first man in

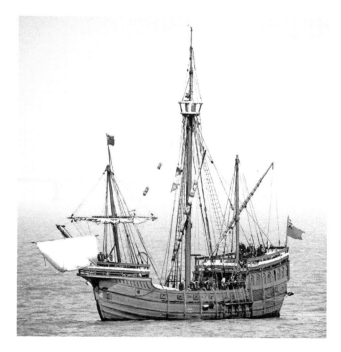

Replica of the *Matthew* sailing out of Bristol. (Shawn Spencer-Smith)

recorded history to step upon the shores of the vast continent we know as America. Cabot returned to a great reception and was encouraged to make a second voyage the following year. This time it was with five ships; neither he nor any of the ships were ever seen again.

In 1991 the City of Bristol began a project to recreate the *Matthew* as part of the celebrations marking the 500th anniversary of Cabot's epic voyage. The keel was laid in 1994 and work began. Everyone involved in the construction was aware of the skill of the builders of the original *Matthew,* who had no modern tools or metal fixtures or fastenings. Even the nails had been made of wood.

Much research went into the design of the new *Matthew* to replicate the original as closely as possible. At 73 feet in length, she seems too small to contemplate a voyage of such magnitude. There is a reason for this; without engines a small ship was easier to manoeuvre in light winds, especially if she found herself among shoals or reefs in strange waters. After her launch and fitting out in 1995, she conducted sea trials that took her to the south coast and across channel to France. On 2 May 1997, 500 years after Cabot's *Matthew* left Bristol, her namesake followed in her wake to set off down the Bristol Channel to challenge the North Atlantic. Two days later came the first of many storms and the gallant ship turned towards Milford Haven for shelter but, with a full gale blowing, they had no choice but to ride it out at sea. It was a good test of the ship and her crew of nineteen. The *Matthew* arrived at her destination in Newfoundland to a euphoric reception, on 24 June 1997, 500 years to the day after John Cabot stepped ashore.

The *Matthew* returned to her home port the following year and continues to bring a considerable sense of pride to Bristol. Ordinarily open to the public, she is the centrepiece of the Bristol Harbour Festival and regularly attends other sea festivals up and down the Bristol Channel. She is a very special little ship, to people on both sides of the Atlantic.

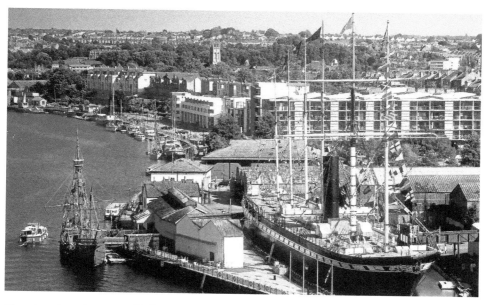

Showing just how small the *Matthew* is compared to the *Great Britain*. (Phil Pierce Photography)

Great Britain

An extraordinary ship, built in an era of many other extraordinary ships, the SS *Great Britain* nevertheless stands in a class of her own. That she still survives at all is a remarkable tale of the seven seas. She was designed and built by Isambard Kingdom Brunel in 1843 in a specially constructed dock in Bristol. Not only the largest ship ever built in Bristol, she was also the world's first steam-powered, screw-driven, iron-clad ship. Her auxiliary engines were used for getting in and out of port; she still relied upon the power of the wind for ocean passages. The *Great Britain* went on to make thirty-two voyages between Melbourne and Liverpool in the years from 1852 to 1875. Hundreds and thousands of Australians today are descended from the 16,000 emigrants who arrived aboard her. In between times she became a troopship in the Crimean War and the Indian Mutiny.

By the time she was thirty years old, the *Great Britain* was coming towards the end of her life as a passenger ship. With engines removed and the passenger accommodation converted to holds, she became a cargo sailing vessel carrying coal to South America. Her last commercial voyage began when she left Penarth on 6 February 1886. Weeks later, she approached Drakes Passage, attempting to round Cape Horn, where the seas are angry, foreboding and dark. A storm was brewing and foaming breakers were being whipped up by Antarctic gales. It was a notorious place where the Pacific and Atlantic Oceans collide, creating ferocious conditions for ships and beckoning sailors to a watery grave. Battered by the storm, the *Great Britain* put back to the Falkland Islands for repair. She was badly damaged and never again left the Falklands as a seagoing ship – yet she still had a role to

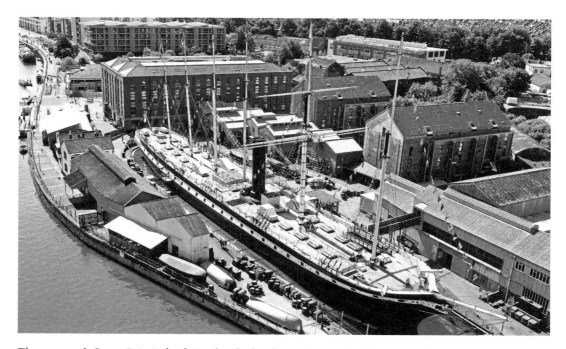

The restored *Great Britain* back in the dock where she was built in 1843. (DroneX ss *Great Britain* Trust)

play. From 1886 she was owned by the Falkland Island Co. and used as a floating hulk to store wool and coal. In 1933 she was towed to Sparrow Cove, scuttled in shallow water and abandoned. For most ships, that would have been enough, but even in oblivion she would prove useful. During the battle of the River Plate in 1939, when the German pocket battleship *Graf Spey* was cornered in Montevideo, the British cruiser *HMS Exeter* was badly damaged and many of her crew killed or injured. She limped to the Falkland Islands, where she was patched up using iron plates torn from the abandoned *Great Britain*.

For the *Great Britain*, the story was not over even then. In 1970, thirty-seven years after she was abandoned, came a world-girdling salvage operation; she was patched up, re-floated and put onto a massive pontoon to be towed back to Britain. It was a voyage that lasted eighty-six days and, on reaching the Bristol Channel, she once again passed Penarth; eighty-four years after setting out on her last voyage. Behold an image of a revenue cutter coming alongside on a misty morning:

'Where from, Cap'n?'
'Penarth,' comes the reply.
'Where to?'
'Bristol.'

She completed her return to the Bristol dry dock where she was built, on 19 July 1970, 127 years to the day after she was launched. She is now splendidly restored and plays host to thousands of visitors every year. Half of *Great Britain's* original mizzen mast is tucked away in a shed in the corner of the site; the other half lies on Victory Green on the waterfront at Stanley in the Falkland Islands, left over from when the ship spent more than eighty years in that far-off archipelago. The *Great Britain*; a truly extraordinary Bristol ship.

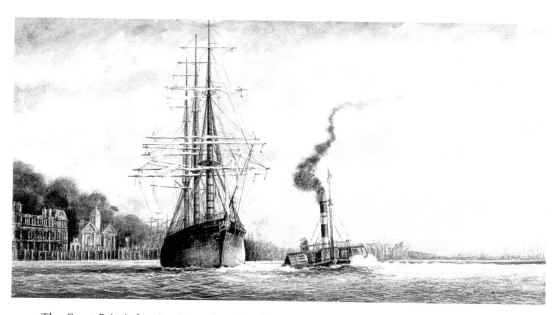

The *Great Britain* leaving Penarth on her last voyage, 6 February 1886. (Owen Eardley)

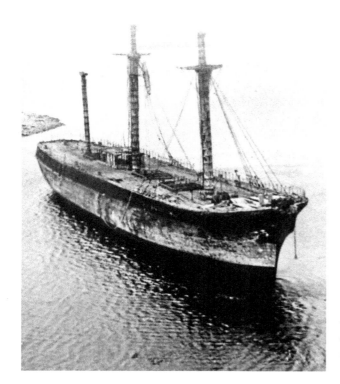

The *Great Britain* in Sparrow Cove, Falkland Islands, where she lay for thirty-seven years. (Falkland Island Museum)

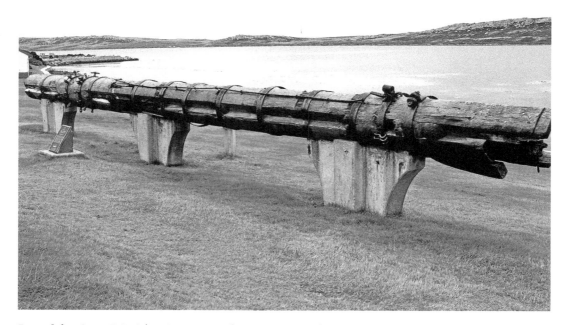

Part of the *Great Britain*'s mizzen mast that remains on the Green at Stanley.

2

Trading Vessels

County of Peebles

I walked a mile along the foreshore to the *County of Peebles* on the outskirts of Punta Arenas, the most southerly mainland town of the Americas. At first, she appeared to be moored to a jetty looking ready for sea. Further inspection found her raked masts had been cut down and were without canvas. Only close-up did you realise that her sailing days were done; she was aground in shallow water with a broken back.

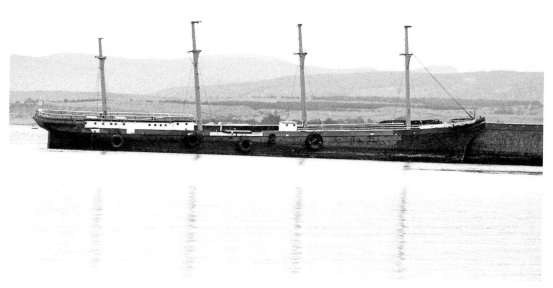

Seen from afar, the *County of Peebles* looks almost ready for sea.

On deck, the *County of Peebles'* sailing days are clearly over.

The four-masted square rigger *County of Peebles* left Cardiff on 7 August 1898 under Captain Dixon, having been sold off to Chile. Since her launch on the Clyde more than twenty years earlier, she had voyaged many times between South Wales and South America. She was a fast-sailing, deep-sea trader and regularly sailed out of Cardiff, Penarth, Barry and Swansea. When her British owners decided to let her go, she was sold to the Chileans and renamed *Munoz Gameno*. She was used as a storage hulk in Tierra del Fuego before being towed to Punta Arenas in 1994 for preservation as a historic vessel.

She lies with two other old ships, more or less one behind the other and leaning against each other by bow and stern. The first two, *Falstaff* and *Hipparchus,* are really only shells of the ships they once were. A doorway cut in the port bow of *Falstaff* follows a boardwalk through the skeleton of her innards and that of *Hipparchus* to emerge on the deck of the *County of Peebles*. An historical ship pontoon with a plan to restore the vessels, especially the *County of Peebles*. The cost was prohibitive however and she is now too far gone.

I took a moment to remind myself that one August morning over a hundred years earlier she had slipped her moorings at the Roath Dock and set out on her last seagoing voyage. A crew member on one of her voyages left us with a remarkably exhilarating record of what it was really like when the *County of Peebles* was driving through the ocean:

Never shall I forget the thrill created by tearing through the mountainous greybeards of the southern ocean at 15 or even 16 knots, the irresistible force driving her cutter through

the boiling seas, the wake of white form, the board-like stiffness of her sails, the roaring hissing rollers, lifting the stern, passing under the ship, and surging ahead with sea and air filled with ozone laden flying spume, every sail, spar and rope humming, roaring or whistling the song of the gale, increasing to a crescendo every time the ship rose on a crest and dying away as she slid into the comparative peace of a deep trough.

Cutty Sark

Last of the tea clippers, the *Cutty Sark* was one of the fastest and most famous ships to sail the seven seas. Her racing voyages bringing cargoes of tea from China to London are legendary; later she was engaged in the wool trade from Australia. One clear night in July 1889, under the gaze of the stars, she overhauled one of P&O's finest steam ships, the SS *Britannia*, herself steaming at 15 knots. The steamer's master witnessed the astonishing sight of *Cutty Sark* crackling along at 17 knots under sail alone.

There was one infamous voyage, though, when she arrived in Penarth to load coal for the US Pacific fleet. Her master, Captain John Wallace, was a fine seaman and a good captain but the ship's mate, thirty-year-old Sydney Smith, was an uncompromising man who gave seamen a hard time. Several crew left the ship in Penarth, with others taken on. The voyage following her departure from Penarth on 7 June 1880 became a famous story of the sea, told and retold in ship's fo'c'sles and bars around the world.

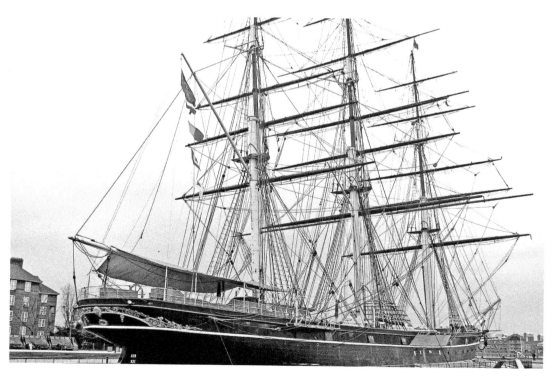

The *Cutty Sark* a year before 2007's disastrous fire.

One of the hands signed at Penarth was John Francis, a black American seaman. As soon as the voyage began Francis was at odds with the mate, Sydney Smith. There were arguments and even a fight. Then, in the Indian Ocean at the height of a storm, Francis twice ignored orders given by the mate. Smith flew at Francis, who had brandished a capstan bar, and grappled it from him. Smith then turned it on Francis, striking him across the head; Francis fell to the deck unconscious and died of his injuries a few days later.

John Francis was not a popular man, even with his own crewmates, but they were incensed with Smith for having killed him and wanted him tried for murder. Captain Wallace had no choice but to confine the mate to his cabin under arrest. When the ship arrived at Anjer for orders, Smith talked the captain into letting him slip quietly over the side to escape. After the ship had sailed for Yokohama, the crew found out what had happened and went on strike; it was left to the officers and apprentices to sail the ship. Three days into the passage, on 5 September, the ship became becalmed in the Java Sea. Captain Wallace grew moody; the strain of the crew strike and guilt over his conspiracy with Smith weighed heavily on his mind. He realised that his career as a ship's master was probably finished. The heat and lack of wind as the ship wallowed listlessly in the idle sea only added to his dejection. Early on the morning of the fourth day, Wallace emerged from his cabin, spoke quietly to the helmsman and silently stepped over the taff rail at the stern of the ship. A boat was quickly lowered but, although the sea was flat calm, no sign of the captain could be found; he seemed to have sunk like a stone. The ship was left in command of the second mate, who almost wrecked her when making the way slowly back to Anjer.

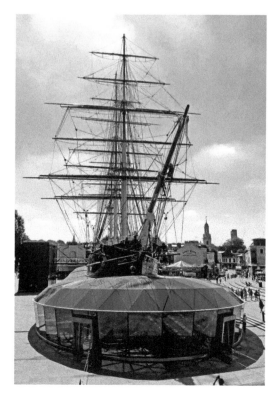

After the fire: the *Cutty Sark* in her glass encasement.

Sydney Smith was eventually arrested and tried at the Central Criminal Court in London for the murder of John Francis. Taking account of the circumstances the jury convicted Smith of manslaughter; he was sentenced to seven years in prison. After release he returned to the sea and eventually became a ship's master himself. Still a hard man but perhaps mollified by his experience aboard the *Cutty Sark*, he died in 1922 at the age of seventy-two.

This fine old ship has been beautifully restored after the devastating fire of 2007, at a cost of £50 million. Already 146 years old, the long-term preservation of the *Cutty Sark* is vital. She is now suspended from the floor to take the strain and weight off the hull, and to allow visitors to walk around below the 'waterline'. It comes at a cost, however; on the surface the whole vessel is semi-submerged in an ugly glass doughnut looking shamefully out of place. A children's merry-go-round carousel alongside does little to improve the vision of this landlocked ship. Sadly, from the outside at least, the *Cutty Sark* seems to be more tourist attraction than maritime heritage.

Polly Woodside

When the *Polly Woodside* slid down the slipway in Belfast in 1885 nobody could foresee that this fine ship would outlive most of her kind and that she would be still afloat proudly displaying the cut of her jib more than one-and-a-quarter centuries later. Rigged as a barque, she was built for ship owner W. J. Woodside and named after his wife. Her maiden voyage was to Newport to load coal for Uruguay. She spent much of her early years carrying coal to South America and returning with a cargo of nitrates or grain, often to Chile, twice rounding Cape Horn in the process. Then, after being sold on and renamed *Rona*, she eventually came to the end of her working life in 1921 after a grounding at Wellington, New Zealand. Her last voyage under sail was to Sydney, before moving to Melbourne as storage hulk, where she remained until eventually falling into disuse. As the last sailing ship still afloat in Australia, rusty, filthy and dishevelled, she was donated to the National Trust of Australia in 1968. Since then, she has slowly and surely been reborn as the *Polly Woodside* of old and is now beautifully restored in her permanent berth in the Dukes and Orr's Dock close to the centre of Melbourne. When I visited her a few years ago I came away from her shore office armed with crew lists, details of voyages in and out of Cardiff and a copy of the diary kept by sixteen-year-old George Andrews on passage to Britain in 1904. This is an extract describing when the *Scottish Lochs* of Liverpool was sighted 120 days out from San Francisco:

> ... we overhauled a ship one morning and sailed nearly side by side about a quarter of a mile off all day. It was just before dark ... the wind increasing she was gradually creeping past us to leeward when they altered their minds and came tearing towards us passing about fifty yards astern. She looked dangerously close. It was about the most impressive sight I have seen. Both of us were doing close on twelve knots and had everything set. We saw a bit of their seamanship too, just as she was passing her flying jib sheets carried away the sail then flapping and making a great noise and flashing fire from the blocks. They soon got it down and stowed, about twenty men going out on the bowsprit.

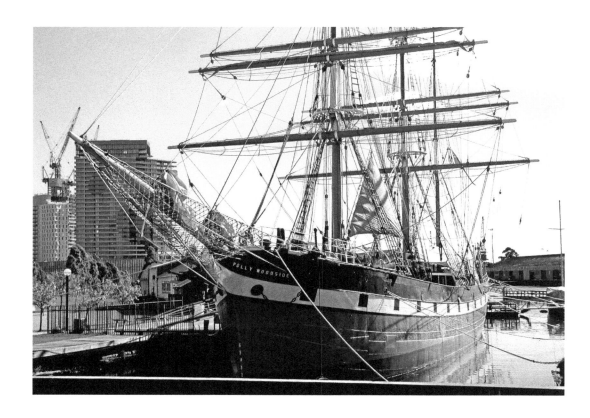

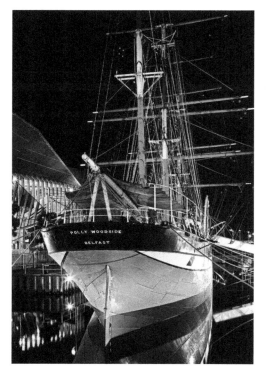

Above: The beautifully restored *Polly Woodside* afloat in Melbourne.

Left: Built in Belfast in 1898, *PW* looking elegant at night.

Irene

Built by F. J. Carver & Son in Bridgwater, Somerset, in 1907, *Irene* is one of the last West Country trading ketches still under sail. She was for many years owned by the Bridgwater Brick & Tile Co., plying her trade across the Irish Sea and the Severn Estuary. Then she changed hands several times and was derelict by the time Dr Leslie Morrish found her in 1965. He took her first to the River Thames and then, lovingly restored, she embarked upon a career as an exclusive charter vessel, crossing the Atlantic many times, and based largely in the Caribbean.

Disaster struck in 2003 when she caught fire while at anchor at Marigot. It began in the stern and quickly spread to engulf the entire ship. Despite the efforts of a fire vessel, *Irene* sank. An underwater survey showed the fire had taken the decks, the deck beams, the frames and inner planking. There seemed little hope that she would ever sail again.

Leslie Morrish had other ideas. He raised the ship, fitted her with a temporary plywood deck and towed her back to Cornwall. This is a truly astonishing story: she was towed over 3,000 miles under sail by the gaff-rigged schooner *Avontuur*. This was an incredible achievement under very difficult circumstances – and so began another four-year restoration.

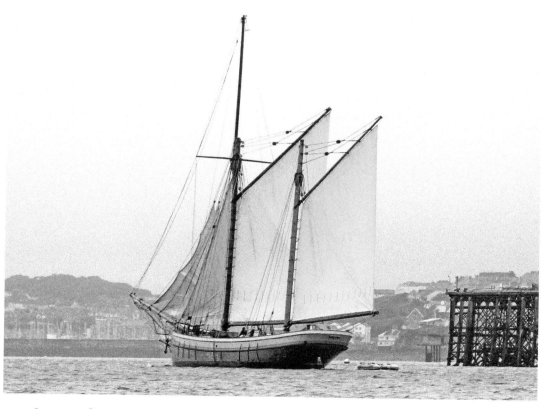

Irene standing out on a grey day at Milford Haven.

In 2012 there was a romantic notion for *Irene* to carry organic beer from Devon to France and olive oil from Spain to Brazil, and perhaps bring cocoa, coffee, and rum back from South America and the Caribbean. Consequently, she was sailing the Atlantic once again. *Irene* has returned to chartering and will be heading to the Canary Islands in 2017.

Joanna Lucretia

Johanna Lucretia is a top-sail schooner built in 1945 at the Rhoose shipyard in Ghent, Belgium. Intended originally as a fishing vessel, she was never used as such and lay unfinished until 1954. Owned by Ber Van Meer, she sailed out of Enkhuizen in the Netherlands before a change of ownership brought her to Plymouth in 1989. In 1991/92 she was refitted at T. Nielsen & Co. in Gloucester and used for private charter to Gibraltar, the Caribbean, and the east coast of the United States.

In 2001 she was purchased by Cutlass Classic Charters and several times chartered. By 2003, however, she had been left in Gloucester Docks, unloved and abandoned. With no one paying her licence fees and mooring charges, British Waterways' patience finally ran out and in 2008 the *Johanna Lucretia* was arrested and subsequently sold to a new owner.

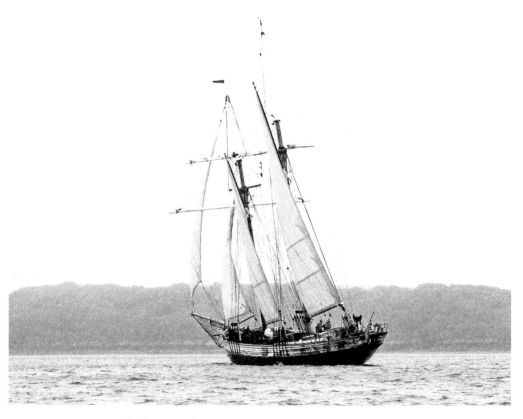

Joanna Lucretia at Milford Haven during the 2010 Seafair Haven.

A refit that followed at Neilson's Yard included having her planking completely re-caulked. Since then she has taken part in the Tall Ships race and maritime festivals including Seafair Haven at Milford Haven in 2010, sailing in company with the West Country Trading Ketch *Irene*.

Sagres

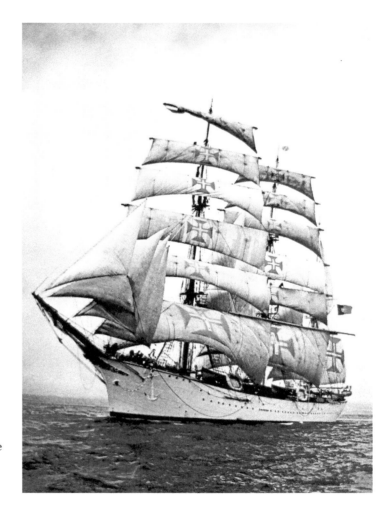

Looking magnificent, the Portugese sail-training ship *Sagres* with twenty-four sails aloft.

Herzogin Cecilie

One of the last great square-rigged sailing ships built and one of the last to survive, the *Herzogin Cecilie* was a four-masted steel barque. She was built by Rickmers of Bremerhaven in 1902 as a cadet ship for the North German Lloyd Line. For thirty-four years she graced the oceans of the world and caught the imagination perhaps unlike any other.

Herzogin Cecilie was in Chile when the Great War began and was interned for the duration. Afterwards, she was allocated to France by the War Reparations Board but passed into Finnish ownership under the command of the legendary Captain Gustaf Erickson. In his ownership the *Herzogin Cecilie* crisscrossed oceans carrying cargoes under wind power alone. She was another to load coal at Cardiff bound for Chile, bringing back nitrates while twice rounding Cape Horn. Even in the 1920s sailing ships were still more economical than steam on long voyages such as this. At 314 feet long with a gross tonnage of 3,242 tons, she was perfect too for the Australian Grain Races. She made a dozen or so voyages from Australia and they made her famous; she won eight of them in succession.

In 1936 the *Herzogin Cecilie* set out on what was to be her last voyage and her last grain race. Port Lincoln in South Australia to Falmouth took just eighty-six days, easily beating her nearest rival, the *Pommern*, by seven days. Her orders at Falmouth were to proceed to Ipswich to discharge her cargo but, two days later, early on the morning of 25 January, in thick fog and rough seas, she struck the Hamstone off Salcombe. Holed in the forepeak, the ship pounded fiercely then settled by her head with her well-decks awash. Crowds gathered at Bolt Head as dawn broke. The Salcombe lifeboat took off twenty-two of the crew, leaving just the captain, his wife, and six crew members on board. Some elements of the watching crowd became unruly and some of the luggage that had been brought ashore was stolen.

For seven weeks the *Herzogin Cecilie* lay stranded on the Hamstone while her 4,500 tons of grain rotted. The stench was appalling and fears of it polluting the beaches around Salcombe meant that the harbour authority was reluctant to allow the ship to be brought in to the quay. The wreck became something of a tourist attraction, with crowds gathering

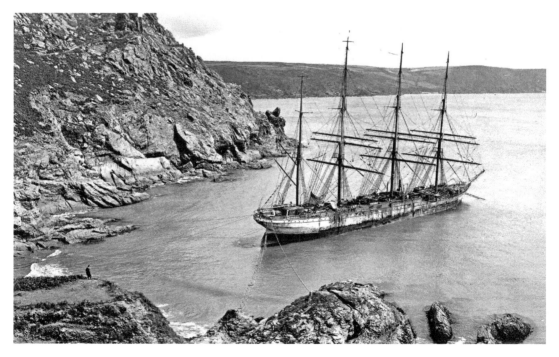

Holed and stranded in Starhole Bay before the storm.

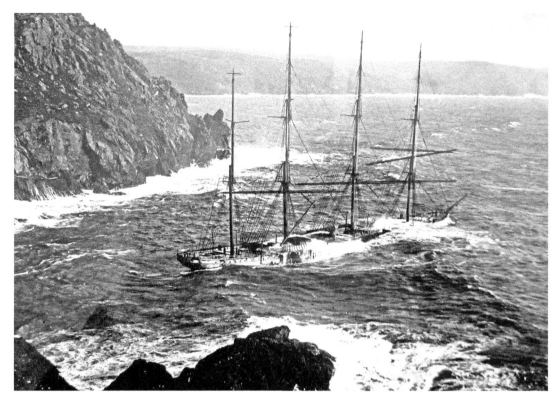

Submerged by the angry sea and beyond salvation.

and farmers charging people to cross their land. Some of the cargo was removed and pumps put aboard. For ten days tugs made repeated attempts to drag her free at the top of the tide until she was finally dragged clear of the Hamstone.

Fearful of disease, the authorities would still not allow the stricken ship to be brought to safety. She was taken into Starhole Bay a natural harbour at the entrance to Salcombe, well protected from the weather and with a safe sandy bed where *Herzogin Cecilie* could sit comfortably when the tide ebbed. Unfortunately, the ship found some exposed rocks on the sea bed. In July came the gales that broke this famous old ship's back; her masts came down and it was clear her end had come. Had she been allowed into the safety of Salcombe harbour she could have been unloaded and repaired quite easily. Instead, a fine, proud ship, one of the last of her type, was allowed to die. All the fittings were stripped, the figurehead was sent to Finland and the remains were sold to a scrap merchant. On a particularly low tide, the bones of the ship may still be seen today; there is a substantial amount of steel plate remaining. It is a popular dive site that provides the opportunity for good underwater photography.

Nornen

Another ship and another wreck. Built as the *Maipu* in 1876 at La Roque Bordeaux the *Nornen* was too early for the building subsidy offered by the French government, but she did benefit from the cargo subsidy. Many of these so-called 'bounty ships' were sold once they reached ten years of age, when subsidies no longer applied; the *Maipu* was no exception. In 1887 she was sold to S. C. Larson in Norway and renamed *Nornen*. Another ten years found her trading with Brunswick in the USA; early in 1897 she arrived at Bristol with a cargo of turpentine and resin. She left the port in ballast on 8 February. In a period of continuing storms, she laboured to make passage down channel and spent some time sheltering in the lee of Lundy Island. As the storm-force winds increased, her anchors dragged and she was driven into Bridgewater Bay to run aground on the Berrow flats. The Burnham lifeboat attended and all the crew were saved but, despite best efforts, the *Nornen* could not be re-floated and she was broken up for scrap. Her bones may still be seen in the sand at low water.

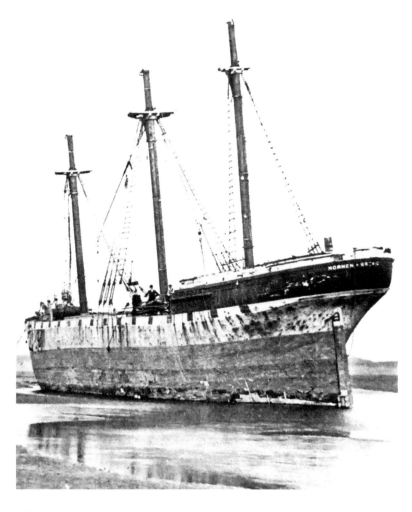

Stranded in Bridgewater Bay, the *Nornen* became a total loss.

3

Antarctic Ships

Scotia

Among the glorious failures of the expedition ships that were to follow – the *Discovery*, *Terra Nova* and *Endurance* – the *Scotia* expedition tends to be overlooked. Yet she was one of the first of the ice ships of Britain's so-called Golden Age of Antarctic Exploration, setting out in 1902 – the same year as Scott's Discovery voyage. As other, more high profile expeditions ventured into the ice, so the *Scotia* faded from public awareness.

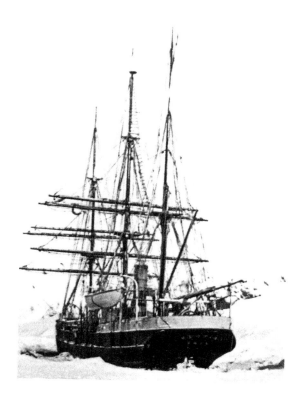

The *Scotia* in 1902, first of the British Antarctic expedition ships.

After her return she was chartered by the Board of Trade, monitoring ice conditions in the North Atlantic following the loss of RMS *Titanic* in 1912. With the onset of the First World War, the *Scotia* began the final phase of her career, as a collier. On Sunday 16 January 1916, the ship left Cardiff with a cargo of coal bound for France. Two days later she was just a couple of miles down channel, off Lavernock point. Smoke was pouring out from both her forward and aft holds. With the help of tugs from Cardiff, she was beached on Sully Island; crowds of people came onto the foreshore to watch. All hands were safely taken off and the fire was fought over the next two days. The *Scotia* was beyond help, however, and became a total loss. Many local people took advantage of the coal scattering the beaches; bags and sacks were filled and scurried away. It was said that *Scotia*'s figurehead ended up in a house in Cadoxton and was chopped up for firewood!

Terra Nova

It was finest Welsh steaming coal that brought the other Antarctic ships to Cardiff: the *Terra Nova, Discovery* and the *Aurora*. The people and the port of Cardiff took the *Terra Nova* to heart, raising more money to help fund the expedition than anywhere else and providing free wharfage and coal; a Cardiff brewery donated a large barrel to be used as a crow's nest. In gratitude, Captain Scott re-registered the *Terra Nova* to the port of Cardiff and promised that the vessel would return to the city at the end of the expedition. The ship left Cardiff on 14 June 1910 and returned three years (less one day) later on 13 June 1913. Captain Scott, of course, was not on board, having perished on the ice with his companions, including the Welshman Edgar Evans.

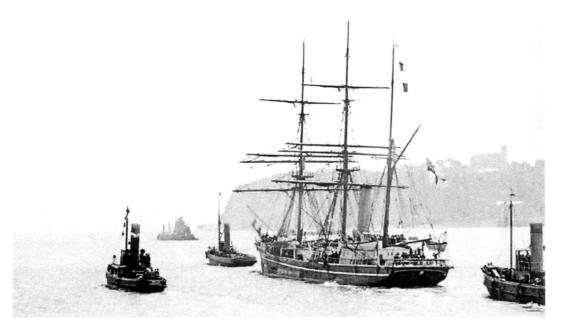

Captain Scott's *Terra Nova* leaving Cardiff on 15 June 1910.

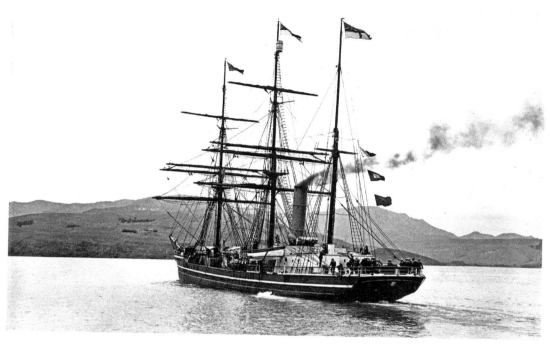

Leaving Lyttelton, New Zealand, with beer-barrel crow's nest fitted.

The *Terra Nova* eventually returned to commercial trade and was delivering stores to Arctic base stations in 1943 when she was damaged by ice. She was abandoned and sunk with gunfire by an American warship as a hazard to shipping. Built in Dundee in 1884 for the whaling industry, her remains were discovered by the research vessel *Falkor* in 2012 off the coast of Greenland.

Before she left Cardiff in 1913, however, her binnacle and figurehead were removed and presented to the City of Cardiff where both are on display. A unique memorial to Captain Scott's ill-fated expedition stands on the Waterfront at Cardiff Bay, close to the iconic Norwegian Church. The *Terra Nova*, arguably one of the most famous of British ships.

Stavros Niachos

One of the Tall Ships Youth Trust fleet, the *Stavros Niachos* is a modern square-rigged brigantine, completed at Appledore in North Devon in 2000. The Trust is a sail-training charity dedicated to the personal development of young people, helping them reach their potential through the medium of sailing. She is one of a significant range of vessels operated by the Trust.

Celebrating the centenary of Scott's expedition, the *Stavros Niachos* took the part of the *Terra Nova* in a re-enactment of the departure from Cardiff in 1910. Moored just ahead of the brigantine was the Royal Navy's ocean survey ship HMS *Scott*, coincidentally also built

Stavros Niachos leaving Roath Basin, 15 June 2010, with HMS *Scott* in front.

The *Stavros Niachos* heading down Channel, just as the *Terra Nova* did.

at Appledore. On the morning of 14 June 2010 the *Stavros Niachos* slipped her moorings from Britannia Quay in the Roath Basin, a brass band playing on the quayside to see her off. She set off down channel following in the wake of the *Terra Nova* of a hundred years before. One small difference was that Scott's *Terra Nova* left at lunchtime while the *Stavros* left at 8.30 a.m. because, as ever, the tide dictates ...

Discovery

The RRS *Discovery* was the first Antarctic expedition vessel specifically built for the task. Designed along the lines of a whaler, she was a three-masted sailing ship, built in Dundee in 1901 for the British National Antarctic Expedition. She was massively constructed with a rounded hull for ease of working in pack ice.

Her commander, Captain Scott, was disappointed to find that *Discovery* rolled badly at sea, reportedly rolling through 94 degrees in the Southern Ocean. She suffered a fatality on her maiden voyage when Charles Bonner fell from the mast and was killed instantly. (Scott lost another crewman in similar circumstances on the *Terra Nova* in 1910.) It was more than three years before the *Discovery* returned to Britain, having been forced to twice over-winter in the ice.

The ship was employed by the Hudson Bay Co. in the years after the expedition and during the Great War made herself useful in carrying munitions to Russia and transporting coal from Cardiff to France for the Western Front Campaign. She returned to load coal at Cardiff before heading south on the British, Australian, and New Zealand Antarctic Research (BANZAR) expedition in 1929. Long retired from active service, *Discovery* is now preserved back at her home port of Dundee.

There are a number of references in this book to the work of Tommi Neilson's yard at Gloucester, which specialises in the restoration of historic ships. With a worldwide reputation for such work, that is no surprise. *Discovery* is the latest vessel to take advantage of their expertise, for restoration work on her masts and rigging.

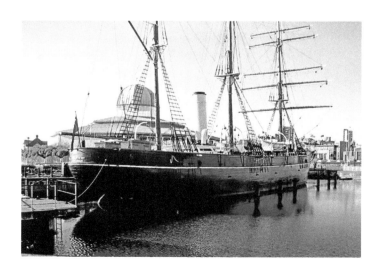

The *Discovery* twice came to Cardiff, and is now preserved in Dundee.

4

History Ships

HMS *Warrior*

For hundreds of years, ships of the Royal Navy sailed the world exploring, protecting and fighting battles – and they did so in sailing ships. However, times were changing in the nineteenth century. When HMS *Warrior* was launched at Chatham in 1860, she was the largest, most heavily armoured, most heavily armed warship in the world. She was a three-masted square-rigger, fitted with auxiliary steam engines. Designed to be innovative, her sheer size and fire power meant that she was a formidable deterrent; she never fired a shot in anger.

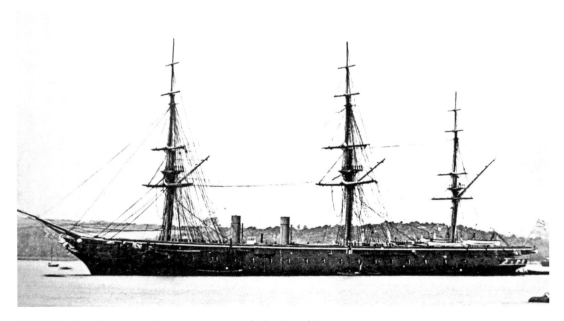

HMS *Warrior* during her days in service with the Royal Navy.

Ironically though, her life as a warship was short-lived. She was soon superseded by faster ships with bigger guns and even thicker armour. By 1871 she had been demoted to coastguard and reserve service. She deteriorated over the years and was put up for sale in 1924, but, with no buyer, she was converted into a floating oil pontoon and towed to Pembroke Dock.

In Milford Haven, *Warrior* was used as a fuel storage hulk.

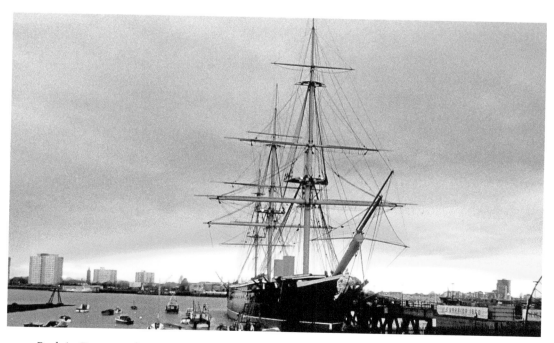

Back in Portsmouth, restored as a maritime attraction.

She was berthed at what became known as Warrior Reach, just to the west of the entrance to Cosheston Pill (East Llanion). The piers and tunnel that gave access to her are still there. Naval vessels and tankers would come alongside to take on or replenish fuel in concealed tanks. Her deck had been completely cleared and covered with concrete; however, down below she still had much of the old accommodation although in rather a mess. Her engines had long been removed and every five years she was towed down river to Milford Dry Dock, where she had her bottom scraped and repainted.

When the oil depot closed in 1978, HMS *Warrior* was passed on to the Maritime Trust and towed 800 miles to Hartlepool, where the world's largest maritime restoration project ever undertaken began. Eight years later, in June 1987, *Warrior* was taken back to Portsmouth, where she now provides an intriguing insight into what life was like aboard an elite warship from the Victorian era. Nearly thirty years on, however, HMS *Warrior* is again in urgent need of further restoration.

Endeavour

There is nothing to suggest that Captain Cook's ship HMS *Endeavour* ever visited the Bristol Channel, although Cook himself seems likely to have done so, since he named the east coast of Australia 'New South Wales' because it reminded him of South Wales. (On the day, he possibly had an imaginative recollection of South Wales.) The *Replica Endeavour* was completed in Freemantle in 1993 from plans drawn when the original *Endeavour* was surveyed during her Royal Navy days. HM Barque *Endeavour* certainly did sail up the Bristol Channel; she had a minor refit in the old Mountstuart dry dock in Cardiff Bay in 2003.

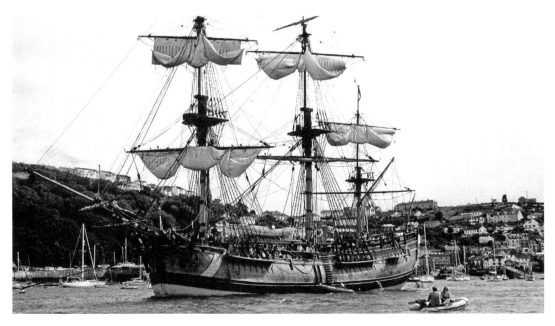

Endeavour in Fowey after leaving the Bristol Channel.

Endeavour's deck from aloft on the main mast.

This was during an incredible eleven-year period when she twice circled the world, sailing 170,000 nautical miles during more than 200 voyages. Around 8,000 men and women experienced eighteenth-century seamanship, and hundreds of others joined day sails in harbours around the world. Many volunteers worked as guides and helped during refits. *Endeavour* visited twenty-nine countries and opened as a museum in 116 ports. By any measure, it was a most remarkable achievement.

During a short sail on *Endeavour* out of Fowey, I talked to a young Australian woman crew member who described a recent passage in a force 9 gale in the English Channel as 'absolutely terrifying'. *Endeavour* signalled her return to harbour by firing one of her large cannons. It was an explosion that shook Fowey and the old waterfront pub, The King of Prussia, to its roots.

The original *Endeavour* was paid off by the Royal Navy, renamed *Lord Sandwich* and used to carry troops to North America during the American War of Independence. In August 1778, she was scuttled with twelve other transports in Newport Harbour, Rhode Island, to blockade the port. Years of researching wreck sites in the harbour have identified some timber remains as similar in many respects to those of the *Lord Sandwich,* previously the *Endeavour*.

Royalist

The current TS *Royalist* is a sail training ship, replacing a previous vessel of the same name and operated by the Marine Society and Sea Scouts. The ship she replaced was a 76-foot steel square-rigged brigantine built by Groves & Gutteridge on the Isle of Wight and launched on 3 August 1971. Almost every week of the year, twenty-four sea cadets from all over the country spend a week on board as part of the crew. Voyages called at many different UK and French ports; in addition to the cadets, there are eight permanent members of crew including the captain.

Royalist has been a regular visitor to ports in the Bristol Channel. On 20 May 1996, she ran aground in the River Severn on a falling tide, some three nautical miles north of the Severn Bridge near Oldbury power station. She had departed from Gloucester and twenty cadets were taken off by helicopter and lifeboat. It left *Royalist* sitting on the ground at an angle of 30 degrees; she was later re-floated quite safely.

Rather more seriously, on the evening of 2 May 2010 a fourteen-year-old male sea cadet was fatally injured following a fall from the rigging while furling sails when the ship was anchored in Stokes Bay, in the Solent. The Marine Accident Investigation Board concluded that the cadet fell because he had unclipped his safety harness trying to move past a fellow cadet. Thankfully accidents of this type are very rare these days, but it wasn't always so. In the days of oceangoing sailing ships, falls from the rigging were all too common and were invariably fatal.

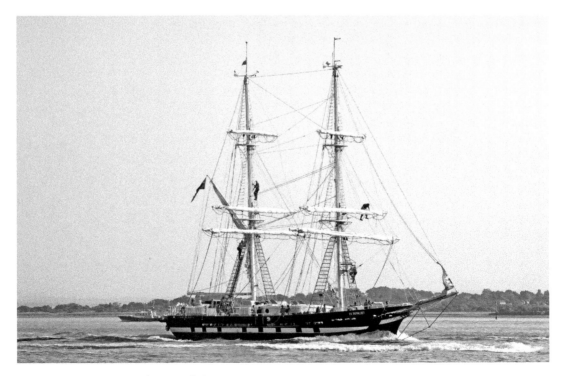

The new TS *Royalist* with crew aloft.

In Loving Memory Of
Alick
Son of John & Rachel Stockwood
of this Town
Who was drowned at Sea by falling from
aloft on the Barque "Penrhyn Castle" in a
gale off Cape Horn, October 6th 1899
Aged 20 Years.

Also JOHN ARTHUR, their Son, Who fell in action
at Guillemont, on Sept 3rd 1916, aged 38 years

Church of the
Holy Cross
plaque.

A plaque on the wall of a thirteenth-century church in Cowbridge in the Vale of Glamorgan commemorates the death of twenty-year-old Alick Stockwood when he fell from aloft aboard the *Penrhyn Castle* while rounding Cape Horn in a gale on 6 October 1899. The *Penrhyn Castle* was a steel barque built in 1890 by Charles Hill of Bristol for Robert Thomas of Liverpool. On 20 April 1915, she left Bahia Blanca for Fremantle with a cargo of wheat and went missing, never to be heard of again.

Maria Asumpta

The *Maria Asumpta*, the oldest tall ship then still sailing, had an interesting history and a tragic demise. Built at Badalona in Spain in 1858, she traded between Argentina and Spain, and was later said to have transported slaves. An engine was fitted in the 1930s and, by 1978, she was in the Mediterranean, renamed *Ciudad de Inca* and without masts or rigging. Two years later Mark Litchfield and Robin Cecil Wright bought her and spent eighteen months restoring her into a sail training ship.

Mark Litchfield and Robin Wright also owned the *Bark Marques,* which had featured as the *Beagle* in the BBC television series *The Voyage of Charles Darwin*. While taking part in a Cutty Sark Tall Ships race in June 1984, the *Bark Marques* sank off Bermuda with the tragic loss of nineteen lives. Later that year *Ciudad de Inca* sailed into Lake Ontario and promptly found herself trapped because of an American lawsuit relating to the sinking of the *Marques*. She was in the Great Lakes for four years and in the winter of 1986 sank in shallow water, although she was quickly re-floated and repaired. Released in 1988, she was renamed *Maria Asumpta* and was once again able to take part in tall ships races.

The *Maria Asumpta* looking splendid under full sail.

The *Maria Asumpta* in harbour.

In 1995 the *Maria Asumpta* had a refit at Neilson's yard in Gloucester. She encountered bad weather returning down channel and sheltered at Porlock, Lynmouth and Swansea Marina. On the afternoon of 30 May she was about to enter Padstow estuary, motoring between the Mouls and Pentire Point, a passage her skipper had used previously. It seemed an innocent situation but, when the *Maria Asumpta*'s engines unexpectedly stopped, she was on a lee shore and it was clear she was in trouble. Attempts to restart the engines failed and the crew hastily raised more sail. It looked for a few moments as though she would just manage to clear Rump Point rocks but, without warning, she struck. A mayday was put out immediately and the crew were forced to abandon ship, with many jumping on to the rocks. Sadly, however, three of the crew were drowned. It was a tragedy that unfolded in front of many sightseers who had come to watch the *Maria Asumpta*'s arrival. The ship's captain, Mark Lichfield, was found guilty of manslaughter at his trial and sentenced to eighteen months' imprisonment. It was a sad day, especially for the families of the three crew members who died, with the loss of a fine ship. It also demonstrated how a moment of cruel fate can expose a wrong decision with tragic consequences.

Passat and *Pamir*

The *Passat* and *Pamir* are invariably linked as sister ships but that is not strictly correct. They were, however, both four-masted steel barques and owned by the same German shipping company. The *Pamir* was built in 1905 and was slightly smaller than the 3,181-ton *Passat*, built in 1911. The ships voyaged for decades, crisscrossing ocean trade routes including many passages around Cape Horn.

During the First World War the *Pamir* remained in the Canary Islands for six years, while the *Passat* was interned in Chile. In the Second World War *Pamir* was seized by the New Zealand government while the *Passat* was confined in Sweden. Both vessels were brought to the Bristol Channel and laid up in Penarth at the end of the Second World War, pending scrappage. However, they were chartered short-term by the British Ministry of Food as floating grain warehouses. In 1951 both ships were sent to the breakers' yard in Belgium but were bought back by Germany before work began. They were refitted to be made ready for sea once more as cadet sail-training ships – symbols of Germany's proud naval tradition.

On 1 July 1957, the *Pamir* left Hamburg for La Plata, Argentina, where she took on barley, loose loaded in her holds. There were eighty-six crew on board, including twenty-two boys and twenty-nine trainees. Leaving Buenos Aries, she headed unknowingly into the path of a hurricane. On 21 September 1957 the *Pamir* put out what was to be her last radio message:

> Four-masted barque Pamir in severe hurricane = Position 35 degrees, 57 minutes North and 40 degrees 20 minutes West – all sails lost – 45 degrees list – Ship is taking water – danger of sinking.

She capsized and sank with the loss of all but six of her crew – an unthinkable catastrophe.

The sinking of the *Pamir* marked the end of the freight-carrying sail training ships. *Passat* was immediately decommissioned to become a museum ship in Lübeck. Today

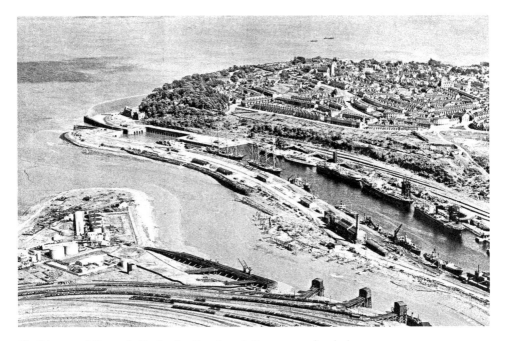

Ely River and Penarth Dock: the *Pamir* and *Passat* can clearly be seen.

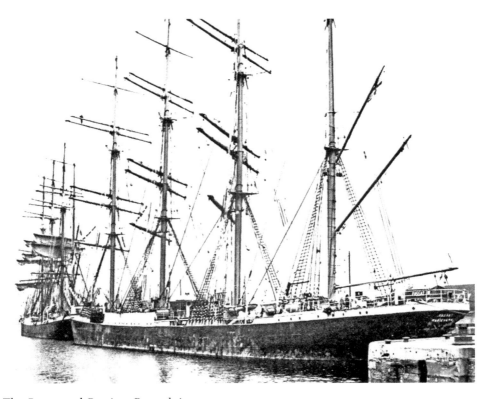

The *Passat* and *Pamir* at Penarth in 1949.

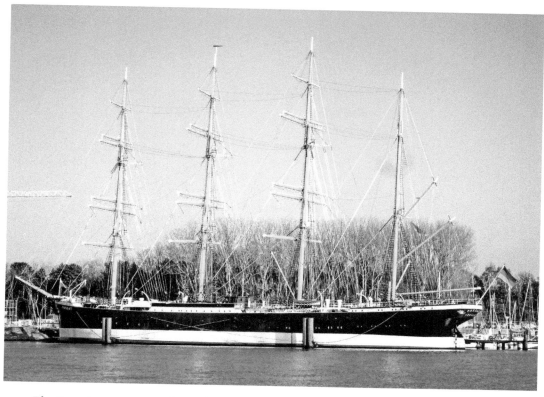

The *Passat,* now preserved at Lübeck in Germany. (Rosa-Maria Rinkl)

she is more than just a museum; she is a meeting place and event venue with overnight backpackers' accommodation, a centre for conferences and a place to get married. The ship is still afloat, gently moving to the swell of the Baltic – a reminder of her glory days. Together with the *Pamir,* she was, after all, the very last windjammer to round Cape Horn with a cargo of grain from Australia, taking part in the last Great Grain Race in 1949.

Gilcruix

The *Gilcruix* was another four-masted iron barque, built in 1886 by the White Star Line. She left Cardiff in 1894, bound for Chile by way of Cape Horn with a cargo of patent fuel. Sixteen-year-old John Masefield sailed on her as an apprentice; it was his first voyage and he was given the job of making the entries in the ship's journal. He described everything about the ship's passage south, particularly her battering when rounding the Horn, the very act of which took nearly a month.

Although captivated by the stories he heard, young Masefield suffered badly from seasickness and became so ill by the time the ship reached Chile that he returned home as a passenger aboard a steamer. His second and only other voyage on a sailing ship was also curtailed – he left ship on arrival in New York and lived on his wits for more than two

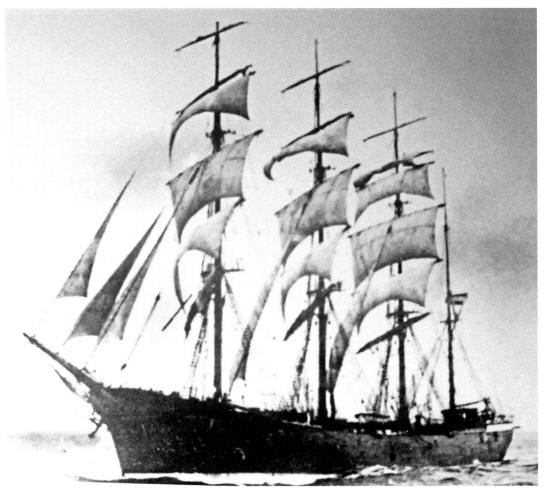

The *Gilcrux*: few vessels have had a greater influence on literature.

years. He went on to write many books, sea stories and salt-laden verse; Masefield loved the sea even if it did not altogether love him back. His best-known poem, 'Sea Fever', captures all the lure and adventure of the sea in just twelve lines. It is the work of a genius. But it isn't *Sea Fever* that is to be found at the waterfront of the modern Cardiff Bay. Close to the spot where the iron barque *Gilcruix* departed in 1894 is Masefield's rather more hard-boiled but nonetheless brilliant poem 'Cargoes', set upon an iron tablet: 'Dirty British coaster with a salt-caked smoke stack, butting through the channel on mad March days ...'

The year after Masefield's voyage, the *Gilcruix* was sold to German owners and renamed *Barmbeck*. At the outbreak of the Great War in 1914, she was arrested by the French cruiser *Chateau Renault* and was broken up in 1923 after a collision with a steamer off St Catherin's Point on the Isle of Wight.

5

World Wanderers &
Racing Yachts

Walkabout

Walkabout: what an appropriate name for a ship built in Fremantle – an Australian indigenous term, meaning 'to wander off'. Her keel was laid down in the early 1950s by two brothers with aspirations to compete in the Sydney to Hobart race. As with many a sailing dream, however, the build took longer than supposed and money grew short. There was little sophistication below deck when the brothers stepped aboard with hammocks tucked under their arms. They sailed her to South Africa, settled down and sold her.

Mike Saunders was born in South Africa, had married an English girl and was living in what was Rhodesia when he began to get itchy feet. Sanctions and worries over security, combined with a sense of adventure, meant that a yacht would be a great escape. He found *Walkabout* moored at a remote swampy lagoon off the coast of Mozambique, a tortuous 500 miles from their landlocked Rhodesian home. She had not been sailed for several years and needed a lot of work, and her owner was asking more than she was worth. He found the money and bought her anyway.

Mike and Liz had four children. *Walkabout* was 33 feet long with one cabin, which works out at around 5.5 feet per person. Nevertheless, on a mad March day in 1972 they crowded aboard, slipped the mooring line and sailed away. Life became very compact, sometimes frightening; people suffered from seasickness and Mike referred to her as a floating slum on washing days. You must wonder about the wisdom of it all, when, having just reached a safe haven after a rough passage, the Mate looks you in the eye and says, 'I am never going to sea again. Do you hear me? Never!'

Six months later the bold, over-crowded little ketch, with the mate still aboard, completed the crossing of the South Atlantic to arrive at Rio de Janeiro. Another six months after that, the Lizard Light hove into view and they arrived at Falmouth, their intended destination. It had been a trial on occasions, but they had made their escape and the whole family had shared an extraordinary adventure and were all the better for it.

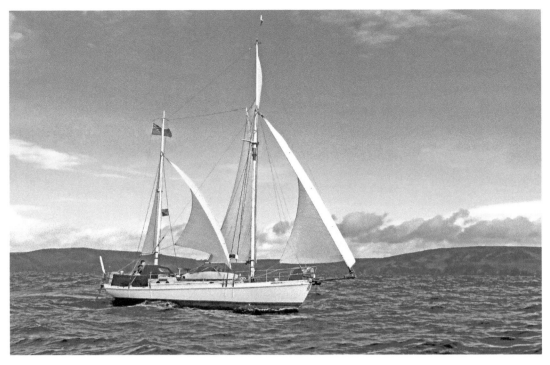

The gaff ketch *Walkabout* under all plain sail. (Dan Darwell)

Mate David Owens (left) and skipper Dan Darwell, heading home on the flood.

In due course *Walkabout* was sold to make way for a bigger boat, yet to be built. It is entirely appropriate that in 2012 *Walkabout* was bought by Dan Darwell. He is a self-assured young man and enthusiastic not only about sailing but about his stewardship of *Walkabout*. He and his wife Rhian and their young family spend their holidays venturing to new parts, including the Baltic and France. The children were sailing before they could walk and are completely at home aboard ship. After several years in Cardiff, *Walkabout* is currently in Portsmouth, a convenient jumping-off point for more adventures.

Challenge Wales

Challenge Wales is a 72-foot thoroughbred that has twice raced competitively around the world. Today, however, she is a sail training charity and works with young people between the ages of twelve and twenty-five, including offering places to older youngsters to compete in the Round the Island Race and the Tall Ships races. The Round the Island race circumnavigates the Isle of Wight and has more entries than almost any other race on the planet. In the 2015 race she saw off the other Challenge 72 yachts and all of the Clipper fleet. It is hard, exhilarating, challenging work but great fun, just needing commitment and the ability for the youngsters to work together as a team.

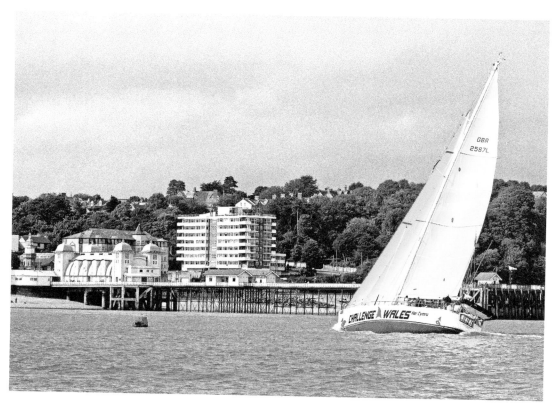

Round-the-world racer *Challenge Wales*, now working with young people in Cardiff.

It isn't just high-adrenalin races, though; families, groups and schools are encouraged to join in, whether for taster sessions, sail-training voyages or for the Duke of Edinburgh scheme. Based in Penarth, when *Challenge Wales* puts to sea with her enormous cream sails glistening in the sunlight she positively lights up the channel.

IT82

In 1972 legendary sailor and yacht designer Nigel Irens opened a sail training school in Bristol and went on to design many successful multi-hull yachts. One of the earliest was *IT82*, a 40-foot trimaran built in Bristol, in which he and Tony Bullimore won their class in the 1982 Round Britain Race. Tony Bullimore went on to sail her to third in class in the 1984 Observer Single-handed Transatlantic Race. The photo shows *IT82* on the River Thames with typical Bullimore aplomb, sailing through Tower Bridge with spinnaker flying.

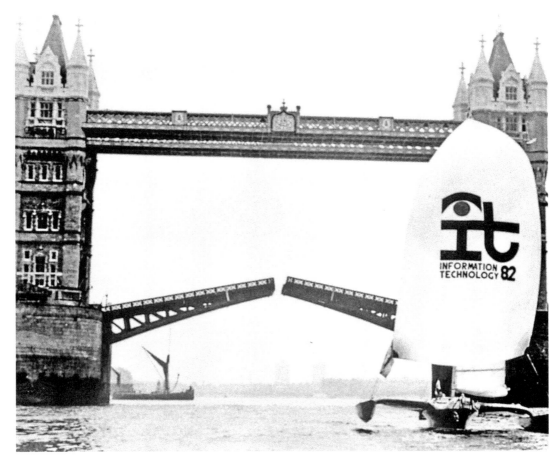

Trimaran *IT82* on the River Thames. (Tony Bullimore)

Spirit of Apricot

After *IT82* came a beautifully sculptured 60-foot catamaran, *Spirit of Apricot,* built and launched in Portishead. Tony clearly still has a soft spot for her, describing her recently as a terrific boat. Not only was she a beautiful sight on the water, she was a state-of-the-art racing machine capable of reaching 30 knots; one of the fastest sailing boats in the world at the time. The pairing of Irens and Bullimore won outright victory in the 1985 Round Britain Race and won every leg in their class in the Round Europe Race the same year. It was no surprise when the two jointly won the Yachtsman of the Year award at the 1985 London Boat Show.

In 1989 Tony set sail from Portishead in *Spirit of Apricot* with a crew of four on a delivery trip to Plymouth, ready for the round Britain and Ireland race. Off the coast of North Devon the giant trimaran mysteriously flipped in calm weather, throwing the crew into the water. Tony woke up in hospital. Three others of the crew were saved but sadly there was no sign of the remaining crewman. The upturned hull was later recovered and brought ashore.

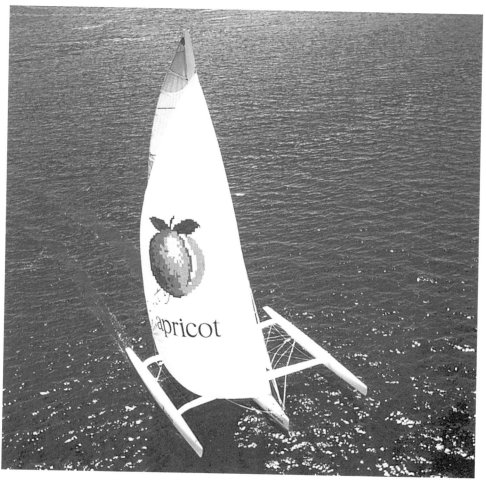

Tony Bullimore's huge trimaran *Spirit of Apricot.* (Tony Bullimore)

Exide Challenger

If Tony Bullimore cut his racing teeth on multi-hulls, it was a mono-hull for which he is best recalled. The photo shows *Exide Challenger* passing Eddystone Lighthouse, having made passage from Bristol on sea trials prior to the Vendee Globe single-handed non-stop around-the-world race. Tony's yacht was a radical design by Angus Noble; built in 1992, it was the first mono-hull ketch fitted with wing masts.

The 1996/97 Vendee Globe rewrote the rules for a race that begins in France with the fleet sailing directly south to circumnavigate the Antarctic continent before heading back to the start. It encouraged sailors to sail too far south into treacherous, icy, Antarctic waters. One competitor lost his life; three more were rescued in the most dramatic fashion; and only six of the sixteen starters finished the course. Virtual way points introduced in later races ensure that yachts keep to higher latitudes.

Equipment failure on *Exide Challenger* early in the race meant she was 1,000 miles behind the fleet in the Southern Ocean. Four days into the new year, the barometer fell dramatically with wind increasing to 70 knots. Tony was running under bare poles and was below deck with hatches shut. There came a loud *crack*; the boat rolled over in one calamitous instant and she did not right herself; the 14-foot, 4.5-ton carbon-fibre keel had snapped off. At 52 degrees south, away from shipping lanes and a long way from land, the future did not look good. For a while the sealed cabin remained relatively dry but then a loose boom outside smashed one of the hatches. Ice-cold sea water poured in to three-quarters fill the upside-down cabin. Tony activated two of *Exide Challenger's* satellite emergency beacons, struggled into his survival suit, and settled down to wait.

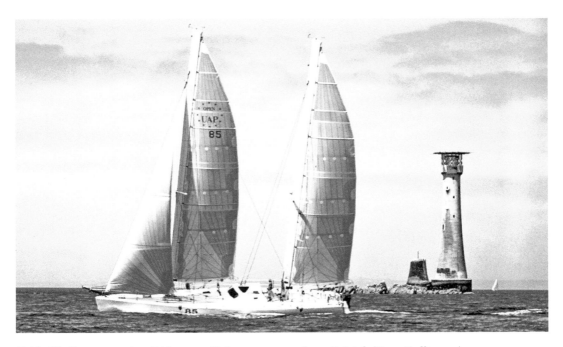

Exide Challenger passing Eddystone Light on passage from Bristol. (Tony Bullimore)

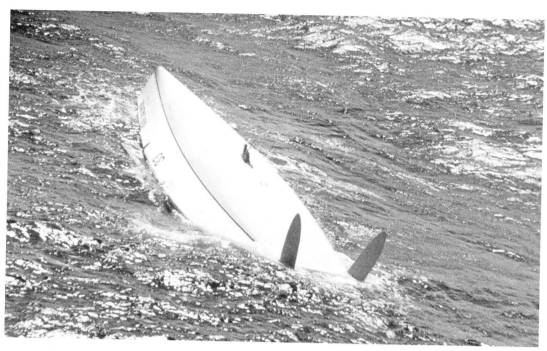

Rolled over but still afloat after five days in the Southern Ocean. (Tony Bullimore)

The signal was relayed to the Maritime Rescue Co-ordination Centre at Canberra, arriving at exactly the same time as a second distress signal from *Pour Amnesty International*, another race competitor. There had already been one other dramatic rescue ten days earlier. *Exide Challenger*'s position was 1,400 nautical miles from Perth. RAAF Orion aircraft were dispatched to the search area, as was the frigate HMAS *Adelaide*, even though no Australian warship had ever previously ventured that far south. The Orion arrived in the area to face a foaming white cauldron of huge seas; trying to find a white yacht looked almost impossible. Incredibly, however, they found the upturned hull of *Pour Amnesty International* with her skipper, Thierry Dubois, clinging to the rudder; they dropped him a life raft. They also found the upturned hull of *Exide Challenger* but there was no sign of life.

It took *Adelaide* four days to arrive at the scene. Everyone knew it was just possible for the skipper to be hunkered down inside the hull but no one held out any real hope after four days and nights in such conditions. A RIB was launched and recovery options considered but, in the end, it was hammer blows on the upturned hull that did the trick. Suddenly there he was, a grey head bobbing up in the water! All the effort, coordination, commitment and daring of the rescuers had come together with the appearance of this battered frame in the icy waters of the Southern Ocean. Tony Bullimore was safe. It shouldn't have happened, but it did; it was a miracle.

The day after the *Exide Challenger* rescue, Gerry Roufs' *Group LG 2* abruptly ceased communicating. In second place, Roufs vanished halfway between New Zealand and Chile. The wreckage of his boat was found on the coast of Chile six months later. The 1996/97 Vendee Globe was a race of attrition that exacted a terrible toll.

Tony's book, written almost twenty years ago, is the most heart-warming book I have read. Beautifully crafted, it recounts the grit and determination of a human spirit pushed to the very limits of existence. Towards the end, back in Bristol, he describes having received a letter in the post from a little girl, the envelope was simply addressed to 'The Upside-Down Sailor'. Quite so.

Coresande

Syd Wright built the 40-foot yacht *Coresande* in 1936 at his yard on a shingle beach in Cardiff's dockland. She has oak frames and larch planking and was built to race. Almost immediately, however, she was laid up until after the Second World War. Her maiden voyage was a passage across channel to Ilfracombe in 1946. She went on to take part in many local races, often very successfully. She was purchased by the Burris family in 1979 and they kept her for the best part of forty years, bringing up their family in her company.

Built to race, *Coresande* has spent all her life in Cardiff. (Mavis Burris)

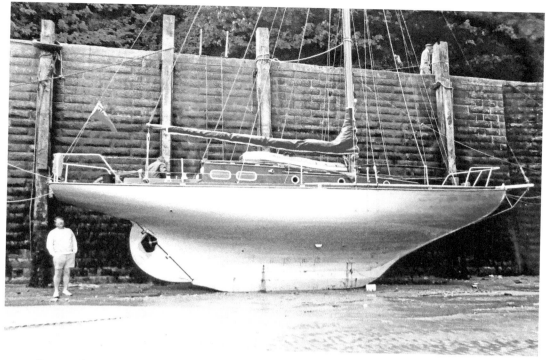

Coresande and skipper Tony Burris waiting for the tide. (Mavis Burris)

Tony Burris was a keen sailor and passionate about *Coresande,* which proved to be a fine family cruising boat. In 1982 Tony and crew sailed her to Northern Spain gaining mileage for his Ocean Yachtmaster. She also visited other ports in the Bristol Channel and beyond, including Ireland, the Isles of Scilly, the Channel Islands and frequently France over the years. She sailed from her home port at Cardiff Yacht Club for over fifty years, during which time *Coresande* had several refits, the last one being in 2013. In March 2014, Tony died suddenly and unexpectedly; it was time for *Coresande* to move on, having been the centrepiece of family life for so long. Although not confirmed, it would be perfect should *Coresande* be passed to World of Boats, located just a few yards from where she was built eighty years previously; a good mooring for a boat that has raced and cruised out of Cardiff for her entire life.

Britannia and *Shamrock*

At the end of nineteenth century the Bristol Channel Yacht Club in Swansea organised the Swansea Bay regatta, which saw many of the magnificent racing yachts of the day coming to the line. The first regatta involving the big yachts took place in 1896 and was followed by regattas in 1909, 1910 and 1913. After the Great War the big yachts returned to Swansea to race in 1926 and 1929. Included among the notable yachts taking part was *Britannia,* owned and raced by King Edward V. The 1926 race was won by *Britannia* with the King at

the helm, with *Westwood* (T. B. F. Davies) second, *White Heather* (Lord Wearing) third and *Shamrock IV* (Sir Thomas Lipton) fourth. There were other races for more modest vessels in the regatta, including one for trawlers.

It was the King's dying wish that *Britannia* should be scuttled; she lies at the bottom of St Catherine's Deep, south of the Isle of White. *Shamrock's* successor, *Shamrock V,* was launched in 1930 as a J Class yacht, which competed unsuccessfully for the America's cup. None of the J Class yachts raced at Swansea, although *Shamrock V, Valsheda* and *Endeavour* are still sailing to this day.

Drawing of *Britannia* leading *Shamrock IV* at Swansea in 1926.

6

Pilot Cutters

The word 'cutter' describes a sailing vessel with a single mast and two headsails at the bow. Bristol Channel pilot cutters were tough, fast vessels that raced each other deep into the Celtic Sea, in all weathers, to be the first to earn the fee for putting a pilot aboard inbound ships. It is often supposed that there was just the skipper and a young apprentice, 'the boy', on board. However, John Clayton (who built the pilot cutter *Faith*), writing in 1909, states, 'The craft are nearly all worked by two men and the pilot – some of the bigger boats may have a boy, but not often.' Rowing or sculling the pilot across to the ship in the punt, frequently in rough seas, was a tough job in any event. These cutters and their skippers were renowned the world over for their skill and mastery of some of the highest tides anywhere. Once in their hundreds, today there are no more than eighteen original pilot cutters surviving. Such is their popularity that new ones are still being built out of wood as pleasure craft or for chartering. All who sail the Severn Sea from Gloucester southwest to the Atlantic will know of the pilot cutters and the part they played in our seafaring history.

Modern pilots still use tough seagoing boats today to reach ships in the channel to guide them safely into port, and it remains a tough job – a Newport pilot sadly lost his life in 2016. The diesel-powered pilot boats of today are still called pilot cutters, even though they no longer have sails; it is the way of tradition.

Mischief

There have been three *Mischief* pilot cutters in all. The first was Swansea-built and sank off Barry in 1888. The second was built in Cardiff in 1906 for the pilot William Morgan, known to all as 'Billy Mischief'. The third was launched from Underfalls yard in Bristol in 2007, ready for chartering in Scotland, although she was seen in Portugal in 2016.

It is the second of these famous names that is the most well-known. She had long finished her service as a pilot cutter by the time she was owned by the Hill family in Brixham in the 1930s. Owner and skipper Mr Hill took great pleasure in her and having his son Alan and daughter Elaine on board as crew. No one goes to sea in a tie and flannels

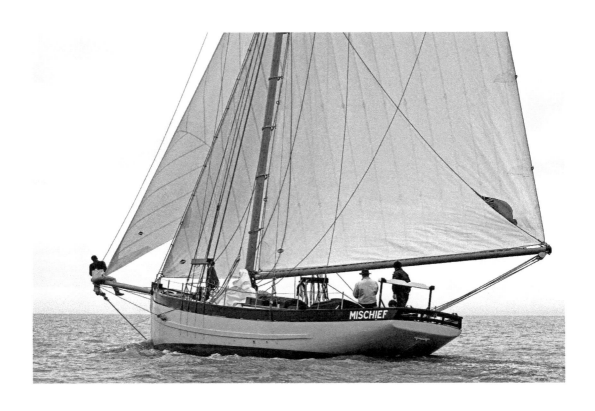

Above: The latest *Mischief* undergoing sea trials after launch at Bristol. (Ben Punter)

Left: Pilot cutter *Mischief* when owned by the Hill family in the 1930s. (Elaine Gray)

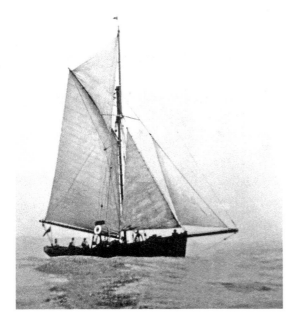

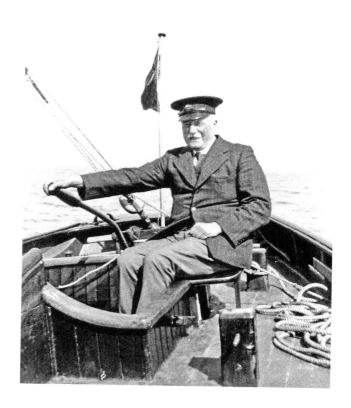

Mischief owner and skipper, Mr Hill, on the helm in the 1930s. (Elaine Gray)

any more. Also in the crew was Harry ('Skip') who looked after *Mischief* in harbour. Alan Hill was killed in the Second World War when his ship went down off Tunis, and *Mischief* was afterwards sold.

She was later purchased by the legendary mountaineer turned sailor W. H. 'Bill' Tilman, who sailed her to some of the remotest and most inhospitable places in the world. It was he who had her hull painted the unmistakable yellow in Valparaiso, Chile, following his epic first traverse of the Patagonian icecap. *Mischief* became the first of three pilot cutters that Tilman lost in Artic waters when, battered by ice, she sank off Jan Mayen Island in 1968.

Races and Regattas

The Cock o' the Bristol Channel Race hosted by Barry Yacht Club and the Bristol Channel Pilot Cutters Owners Association racing at Swansea are two events that still see pilot cutters competing against each other early in the season each year. Other events in Devon and Cornwall follow on. It is a magnificent sight to see a fleet of pilot cutters under full sail gathering for a start line. The Cock o' the Bristol Channel Race has been running since 1936 and in 2016 was won by *Dolphin* (pictured on the front cover of this book). The Swansea race was won by the 1906-built *Mascotte,* a whisker in front of her old rival *Olga.*

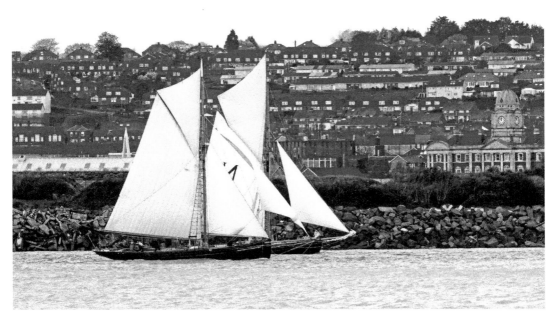

Pilot cutters duelling off Barry 2016, with *Mascotte* edging *Olga.*

Madcap

Believed to be the oldest surviving pilot cutter, the 43-foot *Madcap* was built in Cardiff in 1876 by Davies & Paine. She was a working pilot cutter until after the First World War, when she was sold and converted to cruising. She has had numerous owners since; John Burfield owned her for forty years and only sold her when he was in his eighties. That was in 1993, when Adrian Spence bought her from Chichester and took her to Ireland. From 1998, after the inevitable refit, *Madcap* has cruised extensively, including Iceland and the west coast of Greenland; northwards to Scotland and southwards to Brittany, the Mediterranean, Morocco and the Azores. Adrian recalls a memorable moment on her way to Spain:

> The rudder stock broke when we about 70 miles south of the Scillies. We were able to turn the boat and sail back to the Scillies using the sails, engine, long keel and two buckets. A testament to her balance and handling.

In 2014 *Madcap* was sold away to a consortium in France; she is currently undergoing a major overhaul at La Rochelle. Work is well underway and she will soon be back at sea.

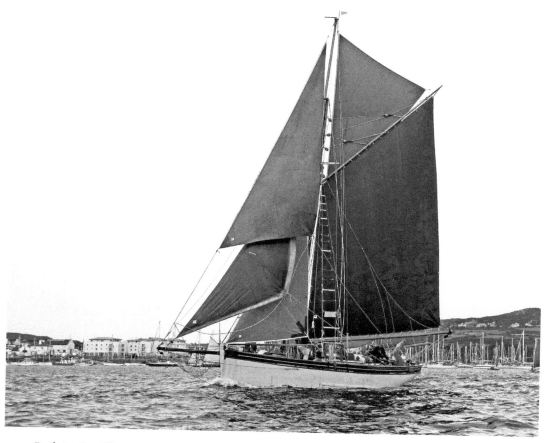

Built in Cardiff, 1875, *Madcap* is the oldest surviving pilot cutter.

Cornubia/Hirta

Built for Pilot George Morrice at Slade's Yard Polruan in 1911, *Cornubia* remained in pilot service at Barry for longer than most. Her story that followed was as interesting as any of the pilot cutters. She was sold away first to London and renamed *Troubador*. In the 1930s she cruised to America, where she had her first engine fitted. Later, she was purchased by the Marquis of Bute, passing the years of the Second World War as a sail training ship for cadets at Rothesay in Scotland. She was renamed *Hirta* after the largest island in the St Kilda group, which formed part of the Bute estate. Mr D. Hare owned her in the early 1950s but loaned her to nineteen-year-old Mark Grimwade, a complete stranger at the time, for almost five years. Mark changed the tiller steering to a wheel he bought for £5 off the hulk of the pilot cutter *Saladin*. She was in Ipswich then and there were no less than six Bristol Channel pilot cutters on the River Orwell in those days.

From 1958, *Hirta* was owned by the Bergius Family, who, together with Ian Denholm, kept her for twenty-four years until she was bought by author and well-known seafarer Tom Cunliffe in 1981. Tom lived aboard her with his family for five years and kept her for

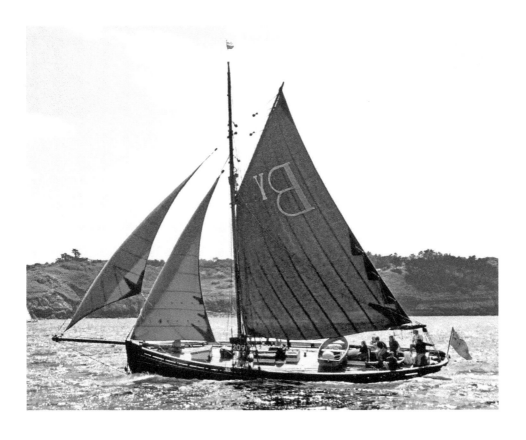

Above: Hirta (ex-*Cornubia*) during the Tom Cunliffe years. (Tom Cunliffe)

Left: Hirta running down wind in Scottish waters in the 1950s.

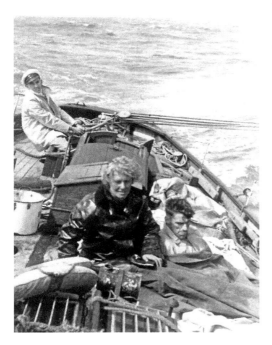

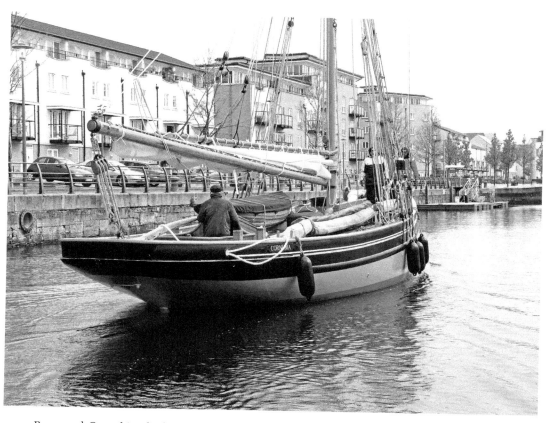

Renamed *Cornubia*, she leaves Portishead 2010 after a refit in Gloucester.

fifteen, sailing her to the Eastern Seaboard of the United States, the Caribbean, Greenland, Norway and Soviet Russia. In 1994 *Hirta* was the star of the BBC television series *Island Race,* when Tom circumnavigated Britain with John McCarthy, the Beirut hostage, and television personality Sandi Toksvig on board. When Tom Cunliffe sold her in 1996, she still had her original mast and boom.

In 2004 *Hirta* went to Neilsons in Gloucester for a complete rebuild, which included a new shape for the stern and a longer boom, re-emerging once more with the name *Cornubia* in 2010, whereupon she promptly won the Cock o' the Bristol Channel race. She is currently doing a splendid job in Plymouth under the banner of the charity Bristol Channel Pilot Cutter Trust, taking disabled children day sailing in and around Plymouth Sound. A remarkable ship with a rich pedigree.

7
Working Vessels

General Picton

There has been a long history of lightships in the Bristol Channel; at least six were strategically placed to warn ships of dangerous shoals and headlands. They were *Milford Haven, Saint Govan* (Pembrokeshire Coast) *Scarweather* (Swansea Bay), *Helwick* (Worms Head) *Breaksea* (Barry) and the *East & West Grounds* (Newport). The latter vessel was built in Bristol in 1885 and spent seventy years helping to keep shipping safe in the Bristol Channel. As the *John Sebastian* she has been restored and is back in Bristol, the only wooden lightship in the world still afloat. Like all the others she is no longer in service – but, have you ever wondered what would happen if any of these engineless guardians got into trouble themselves? Well, they were each equipped with a lifeboat of their own and the *General Picton* is one example. Small but stoutly built, she is now in the care of the West Wales Maritime Heritage Society at Pembroke Dock.

The lightship's lifeboat, the *General Picton*.

Hydrogen

The Thames barge *Hydrogen* was built of pitch pine on oak in 1906 by John Gill & Sons of Rochester; she was a sailing barge rigged as a gaff ketch of 95 feet in length, capable of carrying up to 200 tons of cargo. Her original owners were a firm of chemical manufacturers: Burt, Boulton & Heywood. *Hydrogen* was the last of three similar barges built for the company by Gill & Sons. The first two were *Carbon* and *Oxygen*, with the three together combining to make up the elements of oil. When first built, she carried tanks to transport tar, creosote and oil from the Thames and Medway to Grangemouth on the Firth of Forth.

She is the largest surviving wooden barge and a magnificent sight under full sail despite her age. Not surprisingly, she is on the Register of National Historic Vessels. She continued working cargoes until 1976, when she was finally given a rest. Two years later, however, she was sold to Arthur Bell & Sons Ltd and her hold became a Victorian pub, with a bar running down the length of her keelson. Rather wonderfully, she regularly sailed from port to port around the United Kingdom promoting Bells Whisky and entertaining guests as she went. She is seen here on the beach at Swansea Bay in 1981, awaiting a minor repair.

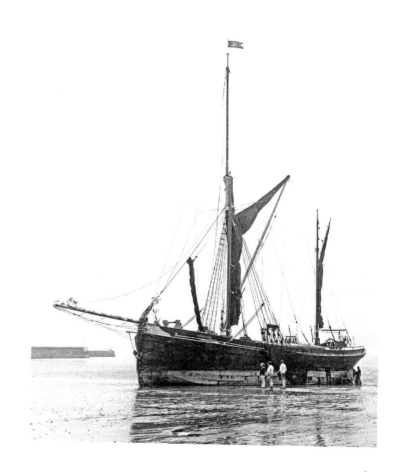

Hydrogen beached in Swansea Bay, 1981.

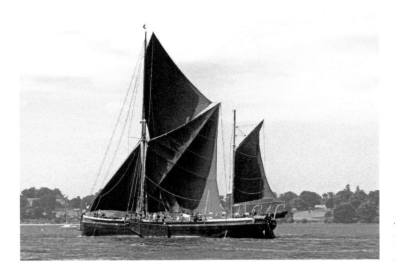

Thames Barge *Hydrogen* looking majestic. (Nick Ardley)

In 2012 *Hydrogen* took part in the Avenue of Sail on the Thames for the Queen's Diamond Jubilee Pageant. She was by then 106 years of age; what would John Gill and his lads made of all that fuss? They would certainly have taken a great deal of pride from the fact that she was still afloat and still sailing the Thames Estuary, her spiritual home.

Vilma

Tucked away at Port Penrhyn on the North Wales coast, from where Welsh schooners once carried cargoes of best slate around the world, lies a remarkable boat yard. In 1996 its owner, Scott Metcalf, was casting about for an old nobby in need of some repair to be able to restore it for himself. What he found was something entirely different, yet inspirational and appropriate. *Vilma* is a boat with a fishing pedigree, ketch-rigged with a wet hold, built by Bronsodde Shipyard in Vejle, Denmark, in 1934 for gill net fishing on the North Sea coast. She had been solidly built of oak on oak with 2-inch planks on 5-inch frames.

By the time Scott found her in Silloth, Cumbria, in 1996 she had been reduced to a motor vessel and was in a very sorry state – a decommissioned fishing boat about to be broken up. Scott could see her potential and promptly bought her, aware that he had a long job in front of him. Over the next five years she was completely rebuilt, re-rigged and relaunched as the last Welsh trading schooner, befitting of her home port. Named *Ceekay* when she was bought, Scott reverted her to what he believed at the time to be her original name of *Vilma*.

Today she is a truly magnificent sight under sail, her black hull gracing the same waters as the schooners of old. Scott, or his son Callum, can be seen scampering aloft on the yardarm, handing the big square sail on the foremast. *Vilma* is a regular at traditional sailing events on both sides of the Irish Sea as well as at the renowned French festivals and has nosed her way up the Bristol Channel to the Maritime festival in Gloucester, providing re-enactments with pirates and cannon on board. Having sailed aboard her several times and witnessed at close quarters the roar of the cannon and muskets, it is a noisy, exciting and dramatic spectacle.

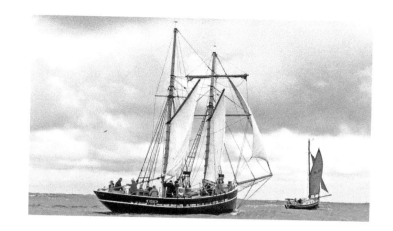

Vilma chasing the Heard 28 *Tir an Og*.

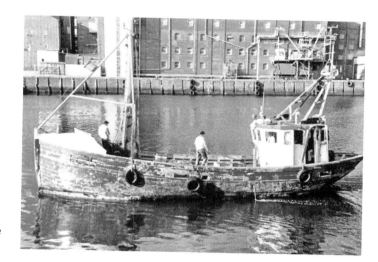

Vilma when Scott Metcalfe found her.

Vilma's gun crew in action.

Lassie of Chester

One of the last Morecambe Bay Prawners, *Lassie of Chester* was built as an auxiliary fishing nobby by Crossfield's of Conwy in 1937 – a Welsh nobby, the last to be built under the walls of Conwy Castle by the Crossfield family. At 36 feet in length, she is also one of the largest nobbies and had extra planking in her hull, as she was intended to fish the turbulent waters of the Liverpool bar. Registered on 18 May 1937 as CH 51 she fished on the Dee throughout the Second World War, with a reputation for fishing in all weathers.

By the late 1980s her fishing career was over and she had been left in the mud to die. It was Scott Metcalfe at Port Penrhyn who once again came to the rescue, carrying out much restoration to her hull and decks. In 1995 she was bought by Doug Smith of West Kirby, who continued her refurbishment, which included a new engine and a complete new interior. *Lassie* now provides exciting racing and adventurous cruising; in 2000 she completed a 1,000-mile round trip to the Brest 2000 Classic Festival, encountering severe weather conditions en route. Competing regularly at various festivals and races, she has many times won 'Best Turned Out Boat' and 'Best Working Sail' awards. She is a handsome ship and a joy to sail, gathering admirers wherever she goes. Her home port remains Port Penrhyn, from where she has graced the waters of Milford Haven and made passage up the River Avon to Bristol.

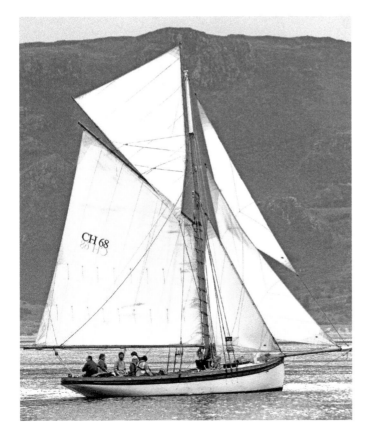

Beautifully restored *Lassie of Chester*.

The Tenby Lugger

Tenby Luggers were open carvel-built boats allowing plenty of room for fishing in the nineteenth and early twentieth centuries. They varied in size to around 25 feet in length and were generally of similar design and rig, and were built by a long series of local builders ending with George Thomas and his successor Palmer Wickland. Some of the local fishermen owned more than one boat, usually crewed by two men and a boy. In 1891 the number of luggers at Tenby was forty-nine; they were used for oyster dredging, long-line fishing, trawling and mackerel fishing. They would often trade with vessels in the Caldey roads, with suggestions that they may even have run outside St Catherine's Island for clandestine meetings, collecting un-customed goods from incoming ships. They would have made ideal vessels for a little bit of smuggling on the side. During the summer many of the luggers fitted with engines took visitors out on pleasure trips; it was likely to have been more profitable than fishing and more honest than smuggling.

Below: The Tenby Lugger *La Mascotte,* with St Catherine's Island behind.

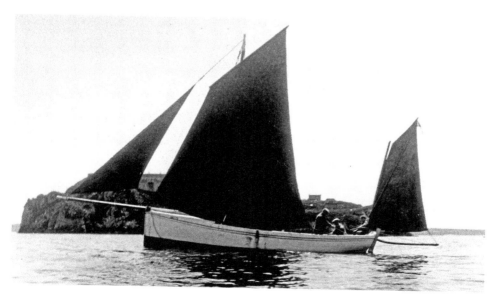

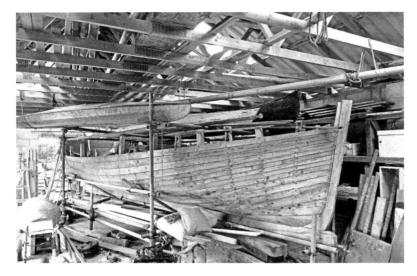

Partly restored
Tenby Lugger,
awaiting a better
shipwright.

The lugger pictured is *La Mascotte,* sailing off Tenby. She was carvel built around 1890 by George Thomas and rigged in traditional fashion with jib, dipping lug and sprit mizzen. Once commonplace, there are now no longer any of these picturesque luggers left sailing. There are currently two incomplete reconstructions that have been started; one is in the care of Milford Haven Port Authority and another is now with the West Wales Maritime Heritage Society at Pembroke Dock. The latter is based on a few old salvaged frames but a poor selection for the new timber by whoever began the rebuild means that it is already showing evidence of twisting, with some planks opening up. It is unlikely ever to be satisfactorily completed. However, the stout-hearted volunteers of the West Wales Maritime Heritage Society have plans to build a replica, taking measurements from the part-completed vessel and using existing line drawings for reference.

Quest

The coble is a well-known and much-loved boat on the north-east coast of England, a breed of boats with Norse heritage, intended to be launched and recovered off the beach, often through vigorous surf. Traditionally, they have no keel, just an abnormally long rudder that was set once the boat had been rowed a short distance to sea. The rudder on *Quest* is 12 feet long; imagine, if you will, the difficulty of setting such a monster onto her pintails in a seaway or even shipping it back on board approaching the beach.

Built by Arg Hopwood in Flamborough *circa* 1928, *Quest* was fished by a syndicate from the slip at North Landing. Around 1958 she was bought by Jim Whitehand, who took her to Boscastle, North Cornwall, where he was harbour master. She was wrecked once on a lee shore from her anchorage at Bude and stove in, and again in Boscastle, when she was torn up by the swell. Jim Whitehand rebuilt her until advancing arthritis meant he no longer could. By the end of the 1970s she was laid up in Boscastle, lying and rotting in the rain. Bart Wordsworth bought her and worked on her for a couple of years in Bristol

until his neighbour wanted his space back. Bart gifted *Quest* to the West Wales Maritime History Society, who undertook repairs to the frames, capping rail and fastenings. She was sailed again but not often; once, when the yard was raised in a light breeze, the old cutched canvas ripped resoundingly, as it was by then more than thirty years old. Perhaps her sailing days are over, but then again perhaps not – there is a plan to save her. She is possibly the only coble in the Bristol Channel.

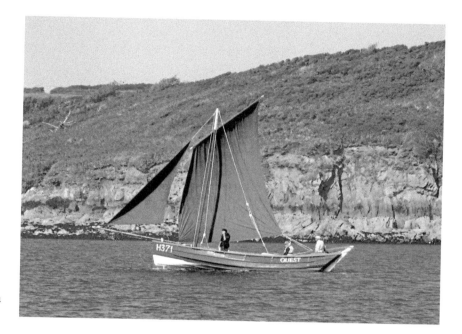

Quest, looking every inch a coble.

Quest, waiting for her next adventure.

White Heather

Cornish working boats have a reputation for their seaworthiness and ruggedness. In the 1880s there were some 570 luggers working out of Cornish harbours, but today there are only around thirty still seaworthy worldwide. Cornish lugger *White Heather* was built by Richard Pearce at East Looe in Cornwall in 1926, and is on the Register of National Historic Vessels. Still very much a working boat, she is registered as fishing vessel FY86. Her 40-foot hull is extended by a 10-foot bowsprit, and a 10-foot bumpkin, giving her a length overall of 60 feet and enabling her to carry five sails.

Many luggers have made epic voyages, including *White Heather,* which set off from Cornwall in 2003, sailing to Africa and Brazil, before returning via the Caribbean.

For some years since then her home port has been Bristol, taking part in races, regattas and harbour festivals in the Bristol Channel including the Gloucester Tall Ships event.

White Heather, a Falmouth working boat out of Bristol.

Sally J

As part of the continuing story of Falmouth working boats, Terry Heard began the 'Gaffers and Luggers' yard on the banks of Mylor creek in 1965. He built the first fibreglass Heard 28 three years later from a mould taken off a working boat called *St Meloris*, a wooden boat he had built two years previously. That first fibreglass boat was named *Meloris*, which, as *Rita*, continues to race competitively in Falmouth to this day. The Heard 28 quickly became popular, catching the eye of cruising and racing sailors.

Martin Heard took over in 1985 after his father died at the age of fifty-seven years. Martin changed the moulding slightly to make it deeper with higher free board for more headroom for cruising. Sadly, Martin himself died at the age of fifty-six in 2009 and his son Sam Heard has continued the family business, building a wide range of traditional Cornish sailing boats. Over 700 boats have gone out of the doors of Gaffers and Luggers in fifty years, 104 of them being the 28-footers.

There are at least two Heard 28s in Milford Haven: *Capraia*, which circumnavigated Britain in 2013, and *Sally J*, which was built in 1980 for Leigh and Jo Rihan, who kept her at Sandyhaven Pill. To celebrate the new millennium in 2000, a Celtic Cruise set out from Ireland, came to the Bristol Channel, sailed around the land to load pasties in Cornwall before heading across channel to Brittany. It was *Sally J* who won the gaff-rig cup in the race, which was held in the newly opened Cardiff Bay lagoon. *Sally J* gained new owners recently but she remains in Milford Haven and is still a beautiful sight with the sun shining on her sails.

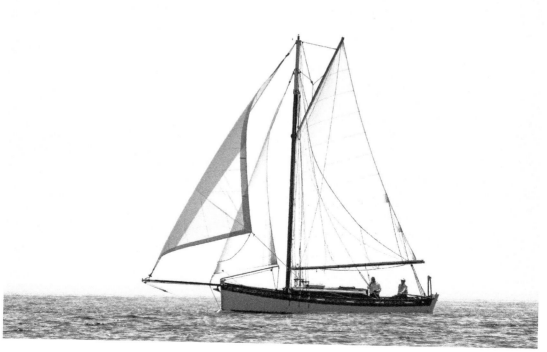

Sally J at the entrance to Milford Haven.

8

Trows & Derelicts

Trows

If pilot cutters were the greyhounds of the Bristol Channel, trows were the workhorses. Even their name (rhymes with 'throws') is a curiosity, said to be an ancient word for troughs. Given their traditional bluff bows, square stern and single barge-like open hold, the similarity might be understood, if a little tenuous. To help protect their open holds, a system of extra canvas dodgers laced up to a rail was developed to increase their freeboard in choppy waters. In the eighteenth century, trows were square-rigged, carrying heavy cargoes throughout the upper reaches of the Bristol Channel and the Severn Estuary. Later ketch-rigged in the nineteenth century, most twentieth-century trows were gaff cutters.

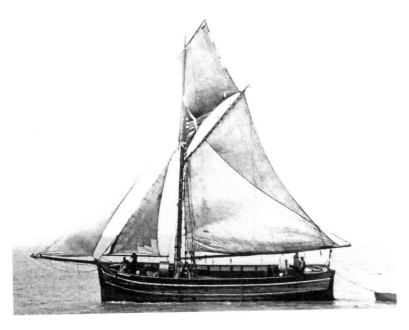

The trow *Industry*.

Hereford Bull

Known as a Wye trow, the *Hereford Bull* is a replica of a particular type of vessel used on the River Wye and the River Severn; based on designs that carried cargoes on the river 200 years ago. She was built in Neilson's yard at Gloucester from wood provided by Herefordshire estates especially to represent the county at the Queen's Jubilee Pageant on the Thames in London in 2012. The 36-foot-long vessel, weighing 4 tons, was equipped with a single square sail. After trials on the river at Hereford, she was taken by road to London to join a thousand other vessels taking part in the Diamond Jubilee. The *Hereford Bull* was crewed by a team of ten volunteers wearing period costume, eight of whom rowed the vessel for the parade.

Unfortunately, the original timber selected for her build was prone to disease and she is currently laid-up at Gloucester pending a decision about her future.

Hereford Bull under construction at Gloucester.

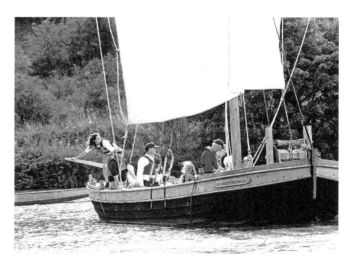

Hereford Bull on the river Wye.

Spry of Gloucester

The last surviving original Severn trow, *Spry,* was built by William Hurd in Chepstow in 1894 and registered at Gloucester on 25 October that year. *Spry*'s log books in Gloucestershire County Archives show that her first owner was William Davis, a Chepstow stone merchant. The vessel made twelve voyages carrying limestone between Chepstow and Cardiff in her first two months after registration. Originally a gaff-rigged sloop she was re-rigged as a ketch in 1913. *Spry* was earmarked to carry supplies to France during the Great War but after twenty years of hard work she was thought unfit for cross-channel passages.

By 1936 she had been converted into a dumb barge and during the 1950s and 1960s was used at Diglis basin in Worcester, which is where she was discovered derelict in 1983. She was acquired by the Upper Severn Navigation Trust in partnership with the Severn Trow Preservation Society and the Ironbridge Gorge Museum Trust. She was moved to Ironbridge Gorge, Shropshire, and completely rebuilt, including new frames and planks of larch on oak.

Back in the water, *Spry* attended the Bristol International Festival of the Sea in 1996, from where she sailed in the Bristol Channel for the first time in sixty years. She has since returned to the Blists Hill site of the Ironbridge Gorge Museums, Madeley, near Telford, where she is displayed under cover in a dry berth. Not everyone agrees with this option – a ship needs water to stay alive – but she is at least safe.

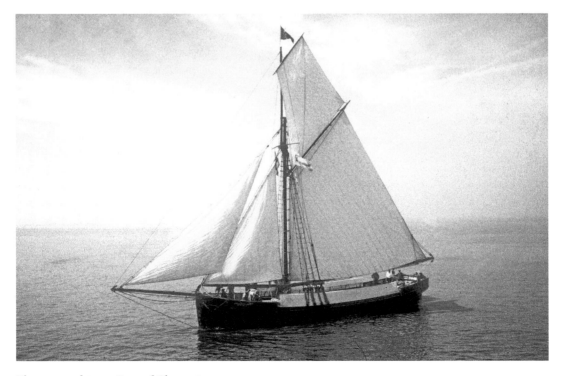

The restored trow *Spry of Gloucester.*

Graveyard of Ships: Purton in Gloucestershire

On a bright summer's day Purton is far from being a ghostly place. Yet you cannot help but feel the tread of the history of the ships that lie beneath your feet – trows, schooners, wooden river barges and concrete lighters – and the men who sailed them, lived and worked aboard them; indeed, the men who ran them ashore at the top of the tide. The majority of these vessels lie buried under mud built up over a century since 1909. There are more than eighty vessels shoring up the bank and gathering silt; the mighty river that once threatened to breach the Sharpness to Gloucester canal has done its job and become its saviour. The last boat to be beached on the shore was in 1965, though many earlier ones are unrecorded nor even plotted on a map; it really is a graveyard of ships. The concrete barges remain whole and are the most visible, but it is the remnants of the wooden ships that are the most beguiling – a few weathered frames, a stem head, a straight-backed corner of a stern poking through the long bull rushes flattened by the last spring tide; a samson post worn down by the work of ropes and men, the charred planks of the schooner *Dispatch*, evidence that nature's decay has been helped by a vandal's bonfire. Little remains now of one of the last sailing trows, the *Edith*, beached here in 1963 and the victim of an arson attack in 1986.

You may stand among them all and feel safe, gazing at the ominous brown river swirling and racing, filling the banks at an alarming rate. The stern of a concrete barge protrudes into the water, its rudder moving to the swing of the tide and the iron tiller hovering free above the surface; you look again in a moment or two and the tiller has disappeared, submerged by the flooding tide. It is a river bank unlike any other, full of maritime industry and endeavour and history, embalmed in Severn Estuary mud.

All that is to be seen of the trow *Monarch*.

Above: The trow *Harriett,* almost buried with her outline still visible.

Left: Sternpost from a bygone age.

Charred remains of the schooner *Dispatch.*

9

Atlantic Gypsies

Happy Quest, the Boat Born of a Heart Attack

Late in 1976 David Grainger suffered a heart attack, which in those days meant at least three months' bed rest. He soon became bored stiff; here he recounts the cure:

> I had always been intensely interested in the design of sailing boats, yachts in particular. I had many books by eminent designers who in those days were happy to publish full line plans and design details of their creations.
>
> Owning a sailing boat since 1952, I had a good idea of what would be my ideal craft and began, flat on my back, to collate vital statistics from designs I admired. My brother bought me a small drawing board I could use on my chest so I could flesh out my musings into something concrete. I had sailed a gaff cutter called *Mignonette* since 1969. Designed by Maurice Griffiths, she was a 28-foot beamy, heavy centreboarder with a hard turn to her garboard and bilge and a flat floor. Though stiff as a church, she suffered from being too slow except in a real blow and in light winds she carried lee helm to windward. My dream was quite different but based on practically the same dimensions – a wide heavy keel, gentle turn to the garboard, steep deadrise and a high, slack bilge; characteristics of the revenue cutters of the early nineteenth century.
>
> Once out of bed and slowly returning to normal life I began to complete the design. The displacement, buoyancy and stability calculations were all initially done long-hand using Simpson's Rule or Mid-Ordinates. Then a friend gave me a planimeter, which helped speed up the final design. A year later I met an American shipwright, Julius Young, who persuaded me that *Happy Quest* should be built and offered to look over the design. He advised drawing out her lines aft another 2 feet and this (I think) was a wise thing to do, for it makes her run easily before a heavy sea and it delivers clean water to her large semi-balanced rudder, meaning she answers surely to her helm. In 1978 the building began. Julius made me a beautiful 1 to 12 half-model, which I used in a homemade test tank to check the displacement, the heeling characteristics and (with a vernier height gauge on an improvised sliding table) the accuracy of my half-breadths. We lofted her on 8 x 4 sheets of plywood laid on the boatshed floor. A pattern was made for the 3-ton keel

casting and a core-box for the centreboard slot. I travelled to East London and selected a log of iroko from Gliksten's timberyard; it was 40 foot long and a 4 foot diameter with no sapwood. They ripped it up to my cutting diagram and kiln dried it before I stacked and sticked it to carry on seasoning. When the keel was delivered I began the first real physical work since my heart attack. With a borrowed magnetic ship-plate drill and a huge tap-wrench I drilled and tapped the 36 ¾ inch keel-bolt holes and many smaller ones. I was going to finish her in two years; it took sixteen! At last she was ready for the water. Naturally I was nervous, would she float on her marks? Would she steer? I need not have worried. Launched and rigged she sat dead on her marks. Cast off and free, she answered to her helm perfectly as we sailed away from the slip to go round to her mooring. The only thing, in my excitement, was that we sailed off under the critical eyes of the spectators with her fenders dangling over the side – despite my wife's loud shouts from the shore!

You may note there is no mention of an engine; that's because there isn't one. David continues to *sail* her to festivals in France, North Wales and Ireland, often racing her and often winning. *Happy Quest* is his boat and he is a true seafarer, sailing her in the manner of our forefathers.

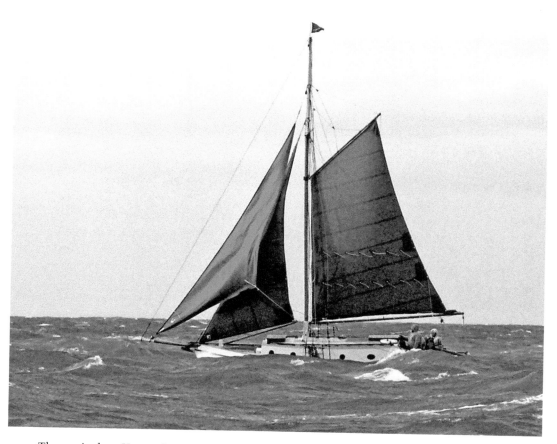

The engineless *Happy Quest* at sea.

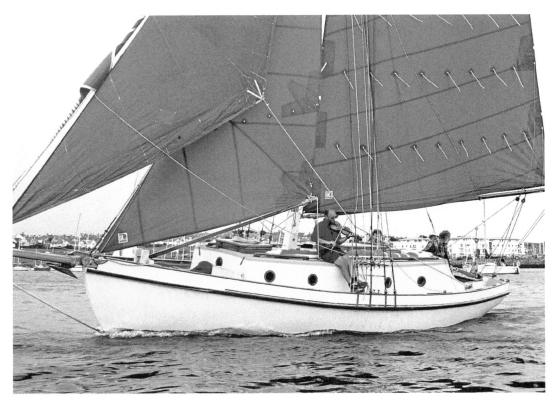

Music is never far away at traditional sailing events.

Lonely Worm

St Donat's Castle, now Atlantic College, is set in spacious grounds and bounded by the sea. It is a place with a long and interesting history, not least the invention of the rigid inflatable boat – the now-ubiquitous RIB. It was in this historic place that Alan Glanville set out to build a boat while teaching at the college. Over seven years he built a gaff cutter based on an early fishing smack but with a ferro-cement hull. In all other respects it was traditional, with timber decks and spars and a solid fuel stove. He called it *Lowly Worm* and referred to it always as a 'he' and not a 'she'.

The hull was constructed in a farmyard, then moved to the ruins of the cavalry barracks for fitting out. *Lowly Worm* was launched in 1990 from the lifeboat slipway and, contrary to some expectations, *he* did not sink beneath the waves. *Lowly Worm* was moored first at Barry before being taken to Plymouth. In due course Alan loaded up his family and sailed him off to a new job in Sweden; a curious boat that was born in a farmyard, grew up as a 'he' in the ruins of a cavalry barracks, graduated to off-shore voyaging before falling on hard times on a mud bank in Chichester.

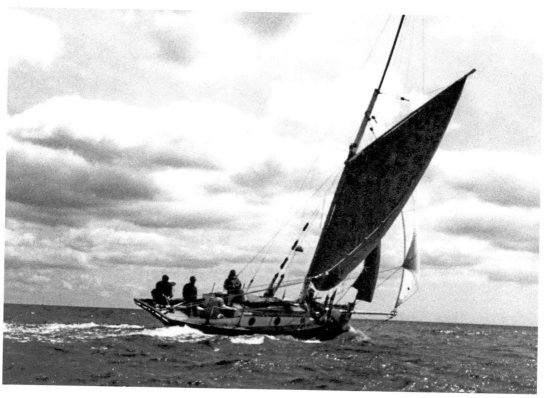

Getting ready for Sweden, *Lowly Worm*'s sea trials.

Working Yacht 1

Another ferro vessel built by one man is *Working Yacht 1*, a lengthened 43-foot (53 feet overall) Hartley & Brookes-designed double-ended gaff ketch (not unlike a Colin Archer) with a balanced sail plan. As her builder, owner and skipper, John Laband knows that, in the event of a mishap, a ferro hull is easy to repair. (He once became closely acquainted with the remains of an uncharted old jetty off Flat Holm. Beaching the boat, he cracked open a new bag of concrete and was soon back under way.) *Working Yacht 1* was built on a farm near Bristol between 1987 and 1991, originally intended purely as a financial exercise to be sold as a hull and deck for fitting out by the buyer. However, a crash in the housing market meant that there was little spare money about and she remained unsold. It was later finished by John and launched as a completed vessel.

John Laband is a committed single-handed sailor, masterfully handling the big ketch. At different times, he has found himself blown a hundred miles out into the Irish Sea or sheltering in the lee of Lundy Island throughout a week-long gale. He once sailed *Working Yacht 1* to Lisbon to find a quiet spot in the harbour and enjoyed a reliable spell of fine weather to reseal his decks. In 2016 he won the Tern Cup for the best non pilot-cutter finisher in the Cock o' the Bristol Channel Race, the 200-mile passage race organised by Barry Yacht Club.

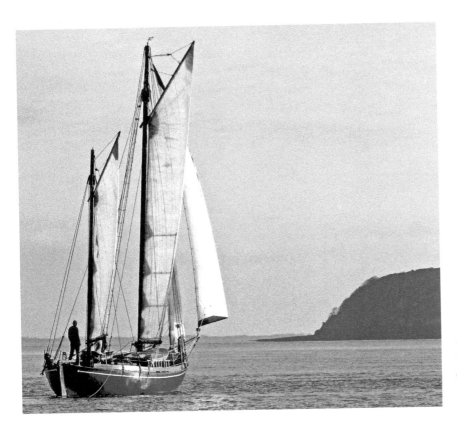

Working Yacht 1 closing Flat Holm in a calm.

Working Yacht 1's skipper working on the foredeck. (Morgan Fox)

Marjorie

At just 40 feet in length, *Marjorie* has an unusual rig; she is a two-masted brig, square-rigged on the main with a gaff mizzen. She was built in 1913 by David Monroe & Sons as a ketch-rigged motor yacht. Her hull is carvel built of pitch pine on oak frames, fastened with copper nails. She has a pointed bow with a plum straight stem and a cruiser stern. *Marjorie* served in the First World War as a Thames River pilot boat, with her original Gardner paraffin engine and ketch steadying rig. In 1938, she was purchased by Captain R. Bell-Davies VC CB DSO AFC. He converted her to a brig and sailed her until the outbreak of war. She was laid up in Weymouth throughout the Second World War after being rammed and sunk. *Marjorie* was refitted in 1946, but a fire on board three years later made a second refit and a new engine necessary. In 1966, she was inherited by Captain Bell-Davies' son, Vice Admiral Sir Lancelot Bell-Davies KBE. For six years between 1975 and 1981 she was sailed in Belgium and Italy. In 2007 *Marjorie* was taken to Sharpness Shipyard & Drydock in Gloucestershire, where she had an extensive refit lasting two years. A new set of sails followed. After seventy-eight years, ownership remains within the family – Lady Bell-Davies, her son and two daughters. *Marjorie* now sails the West Country and the Bristol Channel – her skipper recalls, 'being anchored at Caldey at dawn in May, having just caught four mackerel in the sound for breakfast; watching puffins circle the boat in an empty Skomer North Haven; full sail up channel ... incredible!'

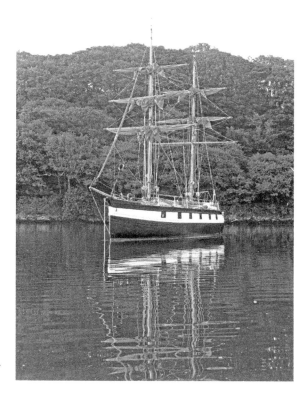

What better place – *Marjorie* at anchor.
(Inky McDonald)

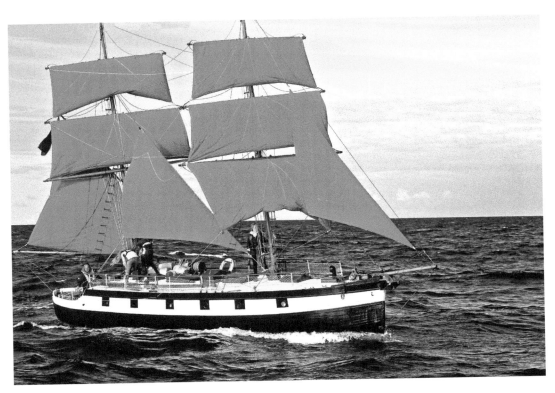

Marjorie in 2016 with her new sails. (Inky McDonald)

Rose of Argyll

Named after the ancient coastal area of western Scotland, the *Rose of Argyll* is a lug-sail ketch, traditionally known as a Loch Fyne skiff; vessels that fished for herring 120 years ago. In fact she was built in 1964 from drawings by James McGruer at the shipyard of James Adam & Sons in southwest Scotland on the River Clyde. Despite her appearance, she was essentially a yacht and cruised extensively in Scottish waters and the English coast. In the 1990s she was sailing in the Gulf of Morbihan in Brittany when she was badly damaged and abandoned to her fate. Thankfully, she was rediscovered by two local seafarers, who carried out a long and exhaustive restoration. Relaunched around 2009, her home is now the French port of Douarnenez, from where she cruises on both sides of the channel, regularly attending festivals of sail. She has no engine and relies entirely on the will of the wind; close manoeuvres in harbour are carried out by rowing or sculling. The *Rose of Argyll*, pictured here in Milford Haven in 2014, looks every inch like the salt-stained herring fleet pedigree she was designed for but never experienced.

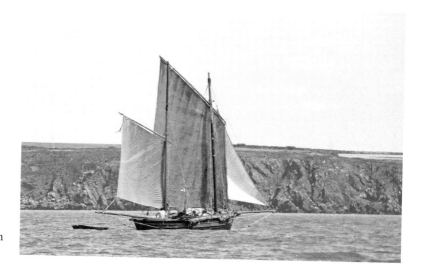

The lug-sailed ketch *Rose of Argyle*.

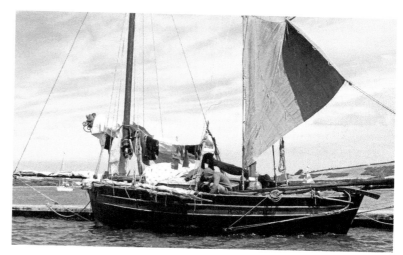

Let it all hang out; the trials of cruising!

Kaskalot

One of the largest and newest tall ships, the Bristol ship *Kaskalot* was built in 1945 at the Andersen Shipyard in Denmark as a three-masted barque. She was constructed of solid oak as an ice-class cargo vessel for trading in Greenland. *Kaskalot* was refitted at Neilson's yard at Gloucester in 2013 as an ocean-going blue-water sailing vessel, blending modern technology with traditional oak. She is much in demand by film makers and has featured in many seafaring sagas. She can be seen making her way down channel from her home port of Bristol, bound for foreign ports early in the season. On her return, she may anchor off Barry to take a pilot on board to guide her back up the River Avon under the iconic suspension bridge to pass into the Cumberland Basin, before proceeding into the historic port of Bristol. Just last year she visited festivals in three different countries, including

sailing from Brest to Douarneneze, in company with hundreds of ships, a truly staggering parade of classic sail as you will find anywhere in the world.

A Bristol-based project is under way to send a tall ship named *Beagle 3* on a two-year world-girdling voyage of awareness and education. *Kaskalot* may yet be off on her greatest adventure yet.

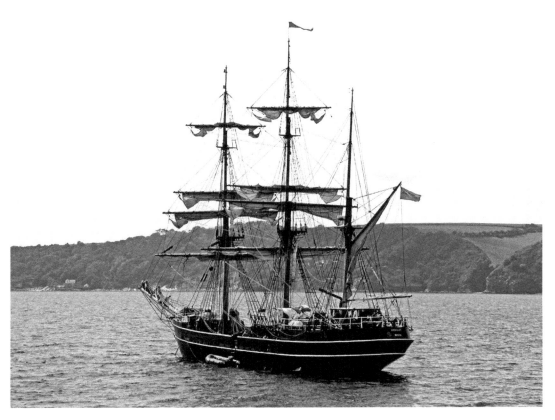

Three-masted barque *Kaskelot* at anchor.

Boatyard on the Beach

Andrew Anderson began building boats on the beach at Penarth in 1906, having taken on the yard previously owned by Harold Clayton. His two sheds were adjacent to the Penarth Dock officers, just where the Cardiff Barrage comes ashore at Penarth today. He built leisure craft from rowing and sailing dinghies to more substantial sailing yachts, including several for Jack Neale of the Neale & West fishing trawler company. Anderson's yachts were pleasing to the eye and performed well; they were highly regarded, although it is suggested that they were not as strongly built as they might have been. Yet today, nearly eighty years after Anderson's yard ceased building yachts, the fact is that at least six of them are still sailing and three have completed ocean passages of epic proportions for such small vessels. So much for not being strongly built.

Anderson's boat sheds on the beach, Penarth.

Emanuel

Commander R. D. Graham spotted *Emanuel* being built at Anderson's yard in 1927 and he bought the 30-foot-long, gaff-rigged sloop a year later. A year after that Commander Graham voyaged from Bridgewater in Somerset to the West of Scotland and the Faroe Islands with his daughter Helen. This, however, was just the beginning. In 1934 he set sail from the Somerset coast on a single-handed voyage to Newfoundland and Labrador, exploring remote coastlines and inlets. After recovering from a mysterious illness during which he was hospitalised for two months, he left the cold northern climate and voyaged south to Bermuda, a passage he described as twenty-three days of unmitigated misery. *Emanuel* returned to Britain via the Azores the following year. Commander Graham sold her not long afterwards; he had plans for a longer journey in a different boat.

In December 1979 Robert and Jan Holden found *Emanuel* 'in need of a little work', lying on the Medina River in Cowes on the Isle of Wight. She was looking dreadfully sad with a lot of rot on the foredeck but she was afloat on a mooring and wasn't sinking. They bought her, took her home to Ramsgate and began an eight-year restoration. Today, *Emanuel* is in immaculate condition and is still in the care of Robert and Jan Holden, her fifteenth and longest-serving owners. The Holdens have sailed her from Ramsgate across channel to Holland and France many times.

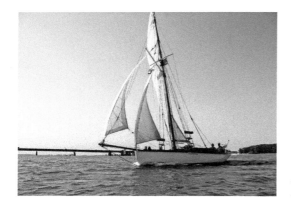

Emanuel in Holland – veteran of the North Atlantic. (Robert Holden)

A fine vessel out of the water, too.

Caplin

For his next adventure, Commander Graham went back to Anderson's yard in Penarth and commissioned another 30-footer, this time a gaff-rigged ketch that he named *Caplin* after small fish he had seen in Labrador. She was launched early in 1938 and, after final fitting out, left Bridgewater on 20 April 1938, a port to which she was destined never to return. For this voyage, Commander Graham was accompanied by a mate, his youngest daughter Marguerite. She was eighteen years old, had never sailed before, and could not cook.

Caplin called first at Bantry Bay in Ireland then across the Atlantic to the Caribbean and the coast of Venezuela and on through the Panama Canal. The boat and its crew were quite famous by this time and they were welcomed wherever they went. *Caplin* next visited the Galapagos Islands before crossing the Pacific. They had reached the island of Raratonga on 8 September 1939 and received the news that the Second World War had broken out. As a retired naval commander, the skipper knew he should return to Britain by the quickest available means; *Caplin* sailed on for New Zealand and, approaching the Cook Straight, they experienced the severest gales of all. The skipper wrote, 'As well as uncomfortable, these gales are so frightening. The ship plunges and waves crash against the hull, so that she shudders all over; if a plank started, we would be under in two minutes.'

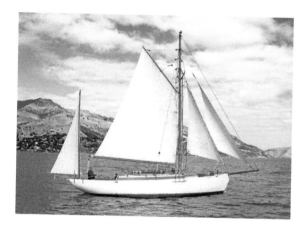

Caplin in New Zealand – built by a Scandinavian in Wales.

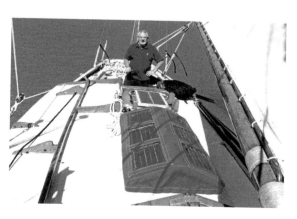

The author helming *Caplin* in Akaroa. (Jan van de Berg)

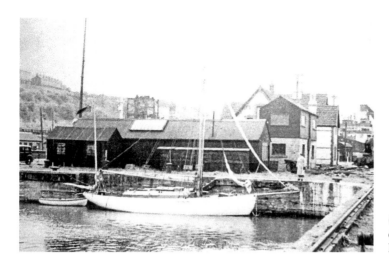

Caplin in Penarth Dock on the day she was launched.

Once safely ashore, and with *Caplin* sold, Commander Graham took a steamer back to Britain, although Marguerite remained in New Zealand for three years before she too returned. *Caplin* was sold in Nelson in the South Island and remained in the Gillies family for three generations before being passing through several more owners. In 2000 she was purchased by Jan van de Berg and he took her to Akaroa Harbour on Banks Peninsula. Akaroa is an extinct volcano where, in some prehistoric time, the sea had broken through to create a wonderful natural harbour and a stunning place to sail. More than seventy years after she was launched at Penarth, I had the privilege of sailing on her several times.

Armorel

Of all of Anderson's boats, it is perhaps *Armorel* that has the strangest tale. Bigger than the rest at 40 feet in length, she was fitted out as a Bermudan cutter rather than the more traditional gaff rig. Little is known of her early history other than that she was launched in 1935 and had been laid up during and after the war.

Bob and Jane Van Blaricom from California decided they wanted to buy an 'English' boat; in 1959 they flew to Britain, where their search took them to Cowes. They made an offer on *Armorel*; the owner was Barry Heath, elder brother of Sir Edward Heath, later to be British prime minister and a world-class sailor himself. The Van Blericoms sailed *Armorel* back to San Francisco, taking over a year, and exploring the Mediterranean and the Caribbean among other places along the way.

One later owner of *Armorel* was Glen Yarborough, a well-known American singer who kept her for fourteen years. In 1978 she was purchased by retiring US Navy SEAL, Chief Petty Officer Bob Diecks. Two years later, Bob sailed *Armorel* under the Golden Gate Bridge, turned left and, in his words, has been going ever since. Bob met his English wife, Caroline, in Tonga and together they have a son, Odin. After cruising the Pacific Islands, *Armorel* fetched up in New Zealand, the second of Anderson's boats to land on those shores. In need of a major refit, her carvel planks were replaced and layered with double diagonal

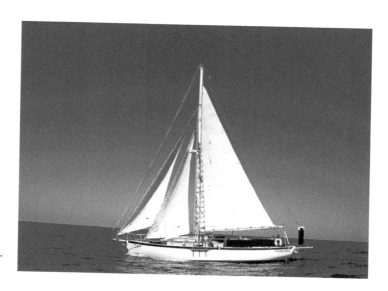

The Bermudan cutter
Armoral in the south seas.
(Bob Dieks)

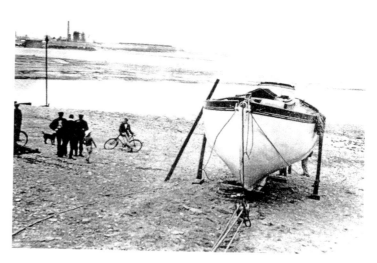

Armorel, ready for
launching on Penarth
beach in 1935.

planking on top. The result is an immensely strong boat, which, at more than eighty years old, is in great shape indeed. I tracked Bob down and went to see him. Home was a small wooden house on the beach at Whangarei Heads in New Zealand's North Island, with *Armorel's* summer mooring in sight of the kitchen window. The living room was littered with sailing paraphernalia and the table covered with newly varnished blocks and boards. A small fishing dinghy and outboard lay in the tumbledown wooden shed on the edge of the beach. It was a Hemmingway-esque existence and our visit was honoured by a bottle of best rum and the firing of a cannon from the back porch. Bob would agree that he is a touch eccentric, but the warmth and generosity towards a couple of strangers turning up on the doorstep was heart-warming. On a guided tour of *Armorel*, above decks and below, it was clear that Bob's passion for the boat he has owned for almost forty years is a beacon shining strong enough to light a passage all the way to the Bay of Islands.

11

World of Boats

The cry of a solitary gull
splits the shining darkness,
pilot skiffs lying alongside,
in muddy furrows,
laced like stranded whales.

Bowsprits heading sou-west,
caught in the ebb and flow
and scattered by Tiger tides.
A sigh of ships beneath the sea,
These silent, shivering, heaving men.

World of Boats is an exhibition centre and wooden boat restoration workshop close to the Roath Basin in Cardiff Bay. It is one of those rare places that does its best to keep Cardiff in touch with its maritime past. Restoring wooden boats among the planks, shavings, sawdust and the smell of oak and pine. It will not be long before the shipwrights and volunteers will be sending the results of their current labours back into the water where they belong.

Elena Maria Barbara

A replica of an eighteenth-century armed topsaill schooner, the *Elena Maria Barbara*, affectionately known as *Elena*, is a type that in times gone by was used by the British and many other navies, including Russia. Fast and manoeuvrable, they acted as messengers between ships of the line, and later for carrying mail and by Customs & Excise. Built in 1995 at Petrozavodsk on Lake Onega in Russia, *Elena* was the last of five similar vessels especially built to celebrate the tri-centennial of the city of St Petersburg. Her design was based upon a set of lines published in 1768.

Even though she is relatively new at a little over twenty years old, *Elena* has suffered from the poor quality of her original build and a lack of maintenance since. She is currently

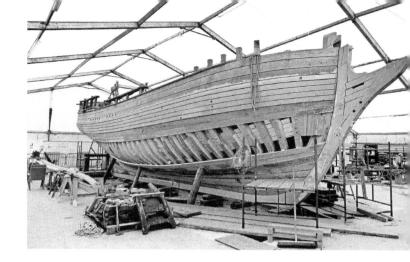

Elena Maria Barbara under restoration.

undergoing a complete refit at World of Boats that has included having new oak frames, deck beams and larch planks. It is a fascinating project that will not only ensure her long-term future but will also improve the authenticity of her original build.

Pickle

Another topsail schooner built in Russia in 1995 was *Alevtina Tuy*, now better known as *Pickle*, similar in type to the Royal Navy's HMS *Pickle*, which was present at the battle of Trafalgar in 1805 and famous for bringing the news of Nelson's death back to London. As *Alevtina Tuy*, she attended the 1996 Festival of the Sea at Bristol and later a spectacle of sail at Milford Haven. She was renamed *Pickle* after being selected to represent HMS *Pickle* at the 2005 Trafalgar bi-centenary celebrations in London. The work for her conversion to *Pickle* was carried out at Neilson's yard at Gloucester. While her namesake had an

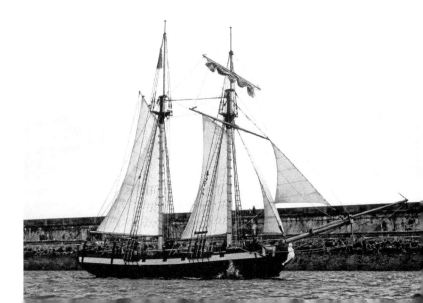

The topsaill schooner *Pickle*.

illustrious and action-packed career before being wrecked in 1807, the schooner *Pickle* has had somewhat mixed fortunes, having also suffered from the poor quality of her original build. However she had a recent refit in Portugal in 2015 and her future looks bright; she is a fine vessel with a proud connection, currently owned by Mal Nicholson and berthed at Hull Marina.

Charlotte

Charlotte has been in the Bristol Channel for forty years at least, first at Watermouth in Somerset and then Cardiff. She is a Morecambe Bay Prawner, probably built around 1908, one of many to come out of Crossfields yards in North Wales and Arnside in Cumbria. Little is known of *Charlotte*'s early history despite research attempts. This weather-beaten gaff cutter was still afloat until brought into World of Boats early in 2015 for inspection; she was found in a poor state indeed. A group of volunteers are painstakingly restoring her, a task that will take several years. Deconstruction has been completed and the rebuild commenced. The mast will need replacing, but the boom, gaff spar and the bowsprit have all been restored and given many coats of varnish or Stockholm Tar – traditional shipwright stuff that leaves the volunteers going home smelling like the inside of a woodman's cottage.

When the job is complete she will be back in the water, as near to her three-quarter decked original design as possible. She will be sailed by volunteer members of the OGA, the Association for Gaff Rig Sailing. The reward for all this endeavour will be the opportunity to give young people a taste of sailing aboard a beautiful traditional vessel that is more than a hundred years old.

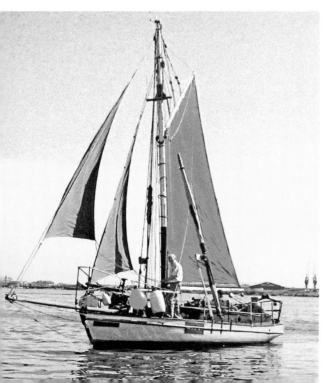

Charlotte sailing in Cardiff Bay.
(Rosie Tomlinson)

Charlotte – removing the over-sized engine. (Charles Harris)

Vigilant

Vigilant was designed by Uffa Fox to compete in the 22 square metre racing class in 1930. Class rules dictate a maximum of 22 square metres of sail and to have accommodation below deck. She has fine lines, a narrow beam, a mast longer than her length and very light displacement. By design, she is fast, sensitive and can plane like a dinghy. A popular class in the Baltic, the USA and South Africa, nevertheless *Vigilant* remains the only one of its type built in Britain.

After launch and sea trials in 1930 Uffa Fox loaded her with food, two good friends as crew, and a dog called Molly, and set sail from Cowes for Sweden to compete in the Royal Swedish Yacht Club Centenary Races at Stockholm. It took seventeen days to reach their destination by way of the Keel Canal. She is not the sort of vessel you would expect to undertake a lengthy cruise of this nature; the accommodation was small and spartan enough for three men and a dog. The summer of 1930 was notable for strong wind and the crew experienced gale-force winds on at least five occasions, though *Vigilant* continued to drive hard and took everything in her stride.

Vigilant was partly restored in the early 1970s and then laid up until 1975. Rediscovered in Norfolk, prior to 1994 she underwent a major refit back to almost original condition. She was one of the stars of the show at the Uffa Fox Centenary Regatta in 1998. In 2010 she returned to Sweden to take part in the 22 square metre Championships at Trosa. *Vigilant* is now in the care of World of Boats in good condition and ready to grace the waters of the Bristol Channel with her special charm.

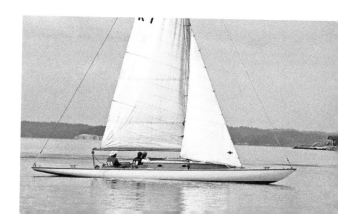

Uffa Fox's 22-metre *Vigilant*. (David Pettersson)

A Glossary of Sails and Ships

Sail plans for barques and brigs can vary, the following are those in common usage:

Barque (sometimes spelt 'bark'): Sailing vessel with three or more masts, square-rigged on the foremasts and fore and aft rigged on the aft mast.

Bermudan rigged: Sailing vessel with three-cornered triangular main sail.

Brig or *brigantine*: Commonly, two-masted sailing vessel square-rigged on the fore mast and gaff-rigged on the aft.

Catamaran: Vessel with two separate hulls connected by a central bridge.

Cutter: Sailing vessel with a single mast and two sails at the bow.

Gaff-rigged: Sailing vessel with four-cornered mainsail set fore and aft with a spar (the gaff) along its top edge.

Ketch: Sailing vessel having two masts with the main mast nearer the bow.

Lug sail: Rigged with four-sided mainsail similar to a gaff but where the sail also protrudes forward of the mast. Simpler rigs, usually found of smaller vessels.

Lugger: A vessel fitted with a lug sail on the main mast.

Mizzen: The hindmost mast, or its sail, on a vessel where the main mast is nearer the bow.

Schooner: Two- or three-masted vessel with fore and aft sails where the main mast is towards the stern.

Sloop: Sailing vessel with a single mast, more often on smaller vessels.

Square rigged: Four-sided sails on 'yards' set across the ship, rather than fore and aft, on multiple masts. Favoured by large ocean-going sailing ships.

Trimaran: Vessel with three separate hulls connected by a central bridge.